IMAGES
of America
NEWPORT BEACH

To my husband, David, and to the memory of my father, Donald N. Gray Jr.

IMAGES of America
NEWPORT BEACH

Pamela Lee Gray

ARCADIA

Copyright © 2003 by Pamela Lee Gray.
ISBN 0-7385-2093-4

First Printed 2003.
Reprinted 2003.

Published by Arcadia Publishing,
an imprint of Tempus Publishing, Inc.
Charleston SC, Chicago, Portsmouth NH,
San Francisco

Printed in Great Britain.

Library of Congress Catalog Card Number: 2003101677

For all general information contact Arcadia Publishing at:
Telephone 843-853-2070
Fax 843-853-0044
E-Mail sales@arcadiapublishing.com

For customer service and orders:
Toll-Free 1-888-313-2665

Visit us on the internet at http://www.arcadiapublishing.com

Contents

Introduction		7
1.	Newport Beach	9
2.	Balboa	47
3.	Corona del Mar	75
4.	The Islands	95
5.	The Harbor	107
Acknowledgments and Sources		127

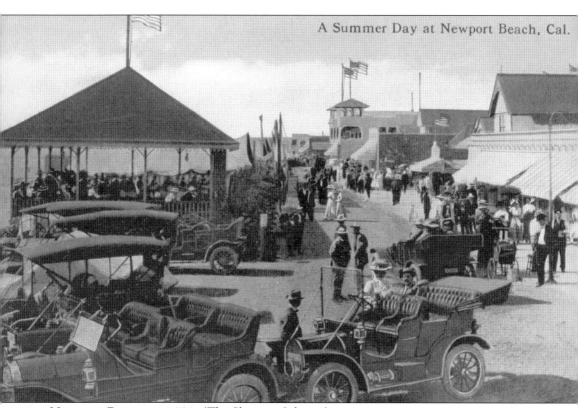

NEWPORT BEACH, C. 1930. (The Sherman Library.)

INTRODUCTION

Arthur J. McFadden, 87-year-old son and nephew of the founding McFadden Brothers, reflected in 1968 to Orange County historian Jim Sleeper, "I doubt if there is any area in the world that has changed more in one man's lifetime than Newport Harbor and the surrounding area." McFadden would undoubtedly be further astonished had he lived to see the changes that have taken place in Newport since that interview. White beaches, palatial homes, piers, internationally celebrated sailing and boating regattas, film festivals, the creation of a pleasure harbor for nearly 10,000 vessels, and the establishment of villages that provide a year-round home to 75,000 residents could not have been imagined even by the most visionary town boosters. Marshes, sandbars, and isolated lots filled alternately with trash, island sewage, and flood water were the reality in the early days. As late as 1915, most visitors regarded Newport area land offerings as risky investments at best, and pure folly at worst. Noting property values today, it is clear the early investors were visionaries, but these owners were not always the ones who were repaid with the profits. Many times the windfalls went to those who had patience, or who simply stumbled upon good fortune at the right opportunity. A small group of residents were intent upon creating a place for year-round living. It would take until well after World War II for the city to refine a course that would allow for creation of the modern villages today.

Change has been a constant in the history of Newport. Island development, new modes of transportation, annexation, harbor improvement and city development were all factors driving change. As successive decades brought new challenges, the villages reinvented themselves. From shipping port to pleasure piers, from a village of sea-related industry (including a salt works and canneries) to boatyards and yacht and sailboat regattas, Newport has transformed itself as year-round residents arrived.

This photographic history shows the expansion of the villages of Newport over the years of development. These views of Newport, Balboa, Corona del Mar, and the islands—many never before published—not only give insights into the past, but explain the spirit of Newport Beach today.

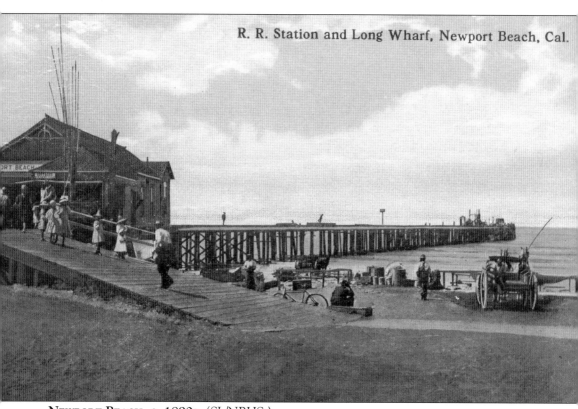

NEWPORT BEACH, C. 1890S. (SL/NBHS.)

One
NEWPORT BEACH

The McFadden Brothers were entrepreneurs with an astute eye for opportunity. They moved west from Illinois, establishing an economic base in San Francisco before setting their sights on the development of a wharf and shipping business in the Newport area. The *Vaquero*, a sternwheeler steamer, demonstrated the feasibility of entering the waters off Newport to create a shipping base in 1876. The harbor was difficult to navigate and limited to smaller, flat-bottom boats. James and Robert McFadden built such a vessel, constructed a wharf, and utilized earlier warehouses to establish a profitable trade, exchanging building supplies for Santa Ana Valley-produced farm goods. Hoping that their port would rival San Pedro and also surpass nearby Anaheim Landing in shipping commerce, the McFaddens constructed a new landing on the ocean side of Newport and lobbied for harbor improvements. They purchased waste lands—swampy "overflow" areas (at giveaway prices)—to build a railroad linking Santa Ana to the new pier, but when San Pedro captured federal harbor improvement funds, the McFaddens sold out.

Others saw potential in the pier, but the Southern Pacific Railroad made sure that there would be no competition from Newport by raising its fees high enough to deter shipping from the area. Business in the northern ports would boom, while Newport was left to look for other avenues for growth. Early residential development did not fare much better. The Dory Fishermen and their families thrived in the area, and were the only year-round residents; in most cases, however, they did not have the money to invest in real estate. The first five houses that were constructed in the town in 1841 were on leased land.

Large-scale residential development was organized by W.S. Collins, H.E. Huntington, and C.L. Landcaster, operating under various firms including the Newport Beach Company, Newport Bay Dredging Company, and the Orange County Improvement Association. The program of harbor dredging, jetty construction, and island development began around the turn of the century, but was halted by World War I and economic depression. It was not until the 1920s that an organized effort for harbor development was undertaken. After cycles of improvement and storm damage, the new harbor opened in 1936, but year-round permanent residents remained difficult to attract.

Salt mines, canning, and fishing were early area industries. Sport fishing, yacht building, and brokering followed in later decades. Newport played an important role in World War II. Shipyards worked on a nonstop schedule. The federal government commandeered local craft to guard the coast, set up military installations in houses and other facilities, and the area developed as an unofficial Army Air Corps rest and relaxation site.

The Newport of today was born after the war. Sail and yacht clubs that had been established earlier in the century built fine clubhouses and docks. Luxury hotels and motels sprung up to house vacationers and the Bal Week revelers who came each Easter week. And at long last, permanent residents came to live, remodeling weekend beach houses and cottages into comfortable, sometimes palatial, estates. Movie stars were attracted to the area for boating and sailing, and some chose to live there. Incorporated in 1906, Newport will soon celebrate its centennial.

Newport Beach today is a collection of villages. Some were annexed, and some were developed from land acquired from the Irvine Company. Certain villages were built on vacant areas that had stood for decades, while others were dredged from the bottom of the bay, literally created from sandbars.

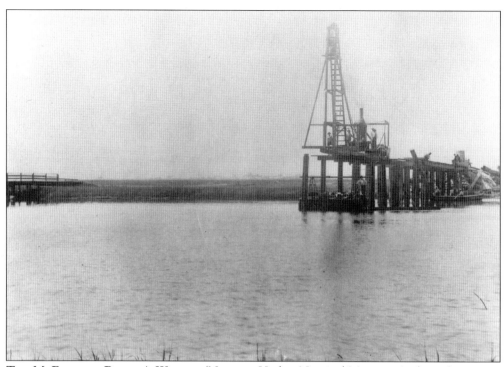
THE MCFADDENS BUILD A WHARF. (Newport Harbor Nautical Museum Archives.)

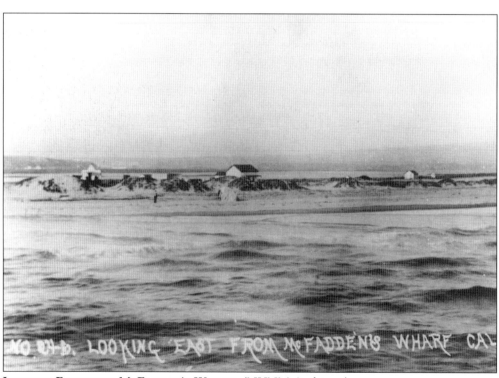
LOOKING EAST FROM MCFADDEN'S WHARF. (NHNM Archives.)

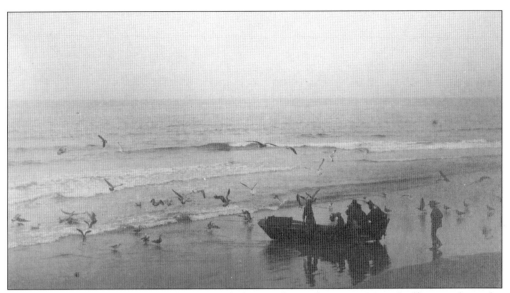

DORY FISHERMEN. Fishermen rose to work during the night, arriving with their catch in the early morning hours. The wives of the fishermen began to sell each day's catch during the 1890s. The first booths were beneath the pier. The women later used the overturned boats as display and sales areas. (Sherman Library/Newport Beach Historical Society.)

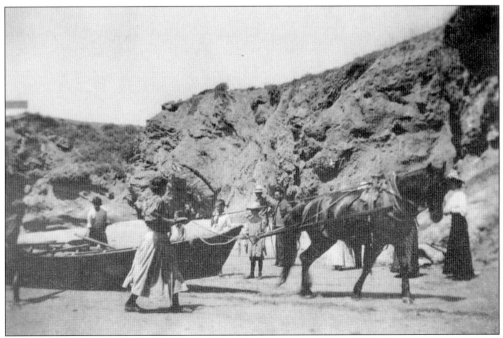

NET OR SEIN FISHING, C. 1905. A popular tourist attraction involved seining. Here a woman directs horses drawing smelt-filled nets onto the shore. (NHNM Archives.)

McFADDEN WHARF C. 1907. The wharf and railroad employed over 100 men who shipped and transported farm goods from the Santa Ana Valley and the San Joaquin Ranch of James Irvine II. (SL/NBHS.)

TALL SHIPS, C. 1890. Early ships carried trade goods from Newport Harbor. The harbor has been officially designated a "Tall Ship Harbor" by the state of California. After the tall vessels were no longer used for trade, several were moored in the bay and used for night fishing. Today's tall ships, such as the *Hawaiian Chieftain* and the replica of the 1812 Privateer *Lynx*, dock at the Newport Harbor Maritime Museum to conduct educational programs for area schools and visitors. (NHNM Archives.)

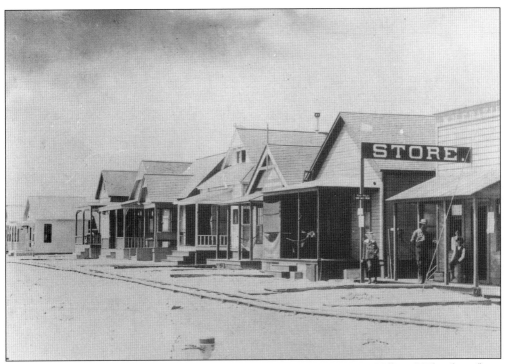

NEWPORT VILLAGE. The Newport Pier area was known as "Newport Village." The dory fleet, fishing, restaurants, and tackle shops were all located at McFadden Place. (SL/NBHS.)

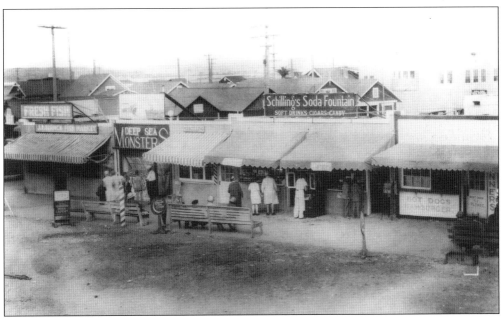

NEWPORT VILLAGE. Schilling's Soda Fountain, a fish market and an attraction claiming Deep Sea Monsters brought in tourists through the 1930s. (SL/NBHS.)

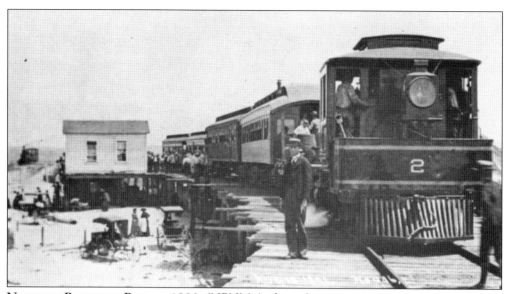

NEWPORT RAILROAD PIER, C. 1900. (NBNM Archives.)

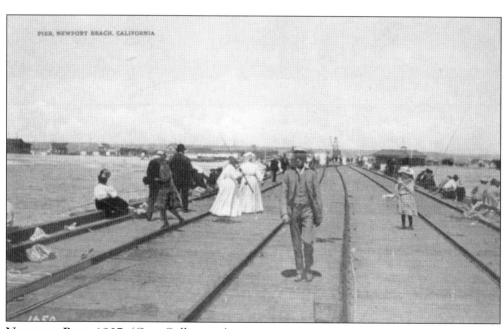

NEWPORT PIER, 1907. (Gray Collection.)

SANTA ANA AND NEWPORT RAILROAD. The railroad had an interchange with the Santa Fe Railroad in Santa Ana. Wood delivered on this railroad would eventually provide most of the lumber to develop early Santa Ana, Tustin, and Orange. The first train traveling from Santa Ana to the wharf arrived on January 12, 1891. (SL.)

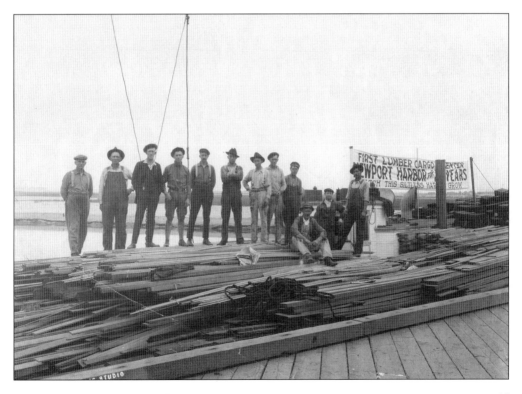

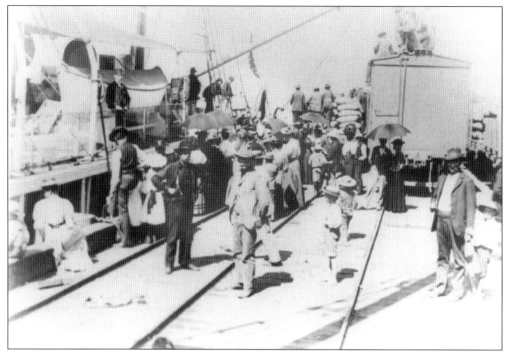

LOADING FREIGHT, C. 1900. The railway ran onto the pier to load building materials and cargo. The locomotive then entered a turntable on the beach where it would be hand-turned and recoupled to the cars, to head toward Tustin and Santa Ana to deliver the new goods. (SL/NBHS.)

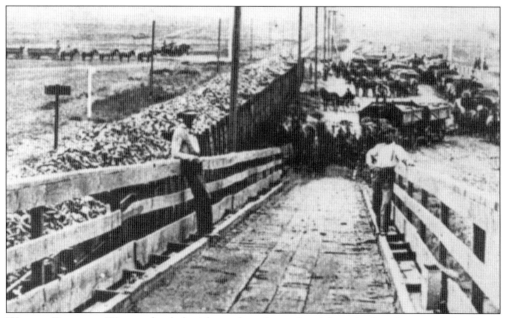

WHARF FREIGHT. Wagons loaded with produce from the rich agricultural areas of the Santa Ana Valley wait to be loaded onto outgoing ships. Lima beans, celery, and barley were early exports from area farms. (NHNM Archives.)

NEWPORT BEACH TENT CITY. Beginning in the late 1880s, campers came to enjoy the sandy beaches on the new wagon route built for railroad commerce. Summer crowds flocked to the beachside pier before hotel housing was in place. Inexpensive, quickly erected tent cities were used for these early visitors. (NHNM Archives.)

BEACH CAMPING. A visit to the beach meant transporting shelter and cooking equipment as well as the entire family. (NHNM Archives.)

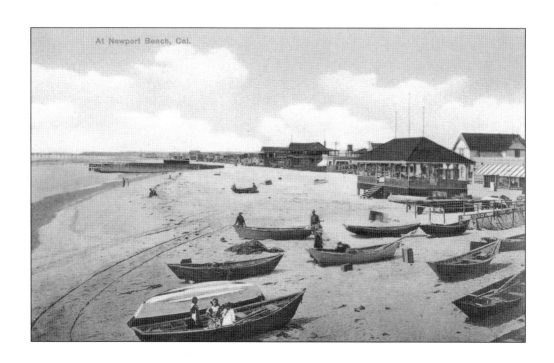

NEWPORT BATHHOUSE AND PAVILION C. 1909. The bathhouse was 500 yards from the wharf. Dressing rooms and bathing suits could be rented by the day. The Newport Pavilion hosted dances every Saturday night, and it was also open for picnickers during the daytime hours every weekend. (SL/NBHS.)

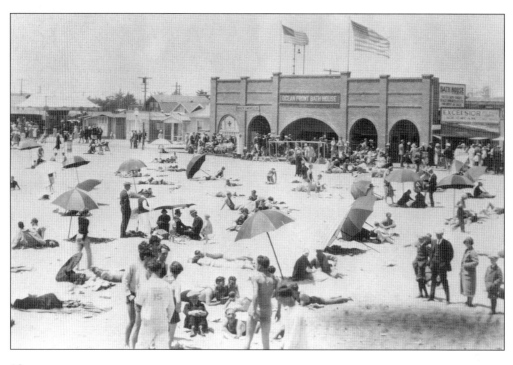

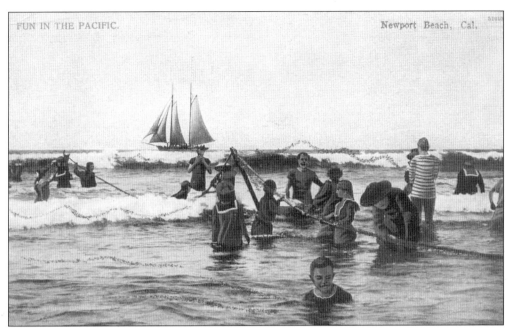

OCEAN BATHING C. 1904. Victorian morals demanded that bathing suits resemble everyday clothing. It is not surprising that swimming was difficult in these suits. Bathers were not experienced swimmers, and to prevent drowning, a heavy rope extended out into the surf to steady waders. (Gray Collection.)

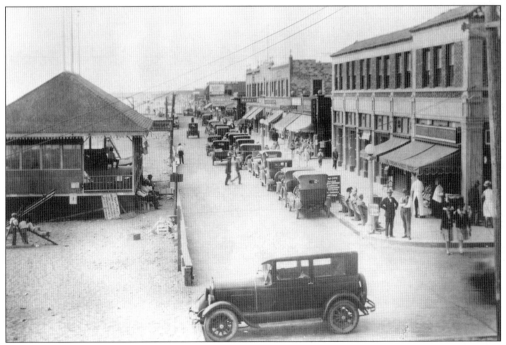

OCEAN FRONT PAVILION. William S. Collins sold the Newport town site to Stephen Townsend. The real estate deal included the former Sharp and McFadden Hotels and areas in West Newport. Townsend built the square oceanside open-air pavilion. (SL/NBHS.)

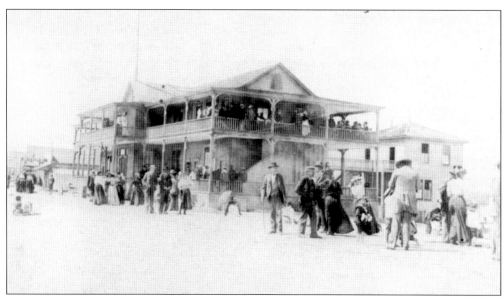

NEWPORT HOTEL. Emmet Brockett is given credit for erecting the first new structure in Newport, but the Newport Hotel was built soon after for visitors who arrived on the railroad. The hotel was located west of the pier on the ocean front. (SL/NBHS.)

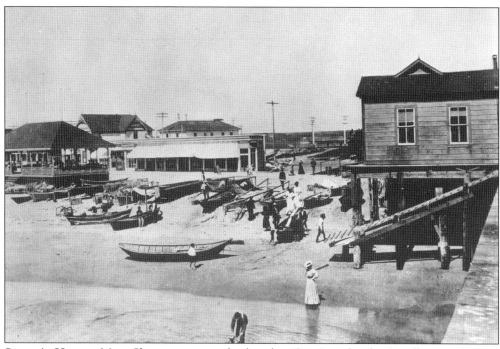

SHARP'S HOTEL. Mary Sharp constructed a hotel at San-Juan-by-the-Sea (later to be San Juan Capistrano). Recognizing that transportation would come first to the new pier, Mrs. Sharp had the structure dismantled and relocated at Newport. The hotel was one of the first buildings in town. (SL/NBHS.)

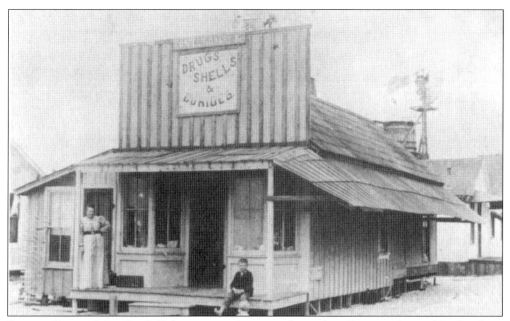

SALTER STORE. Mrs. Sarah Salter operated a general merchandise store located in the front of her house near the pier. She purportedly practiced medicine, in addition to dispensing medicines and tonics. (NHNM.)

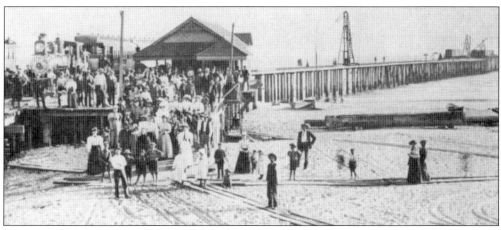

NEWPORT BEACH, C. 1895. (NHNM Archives.)

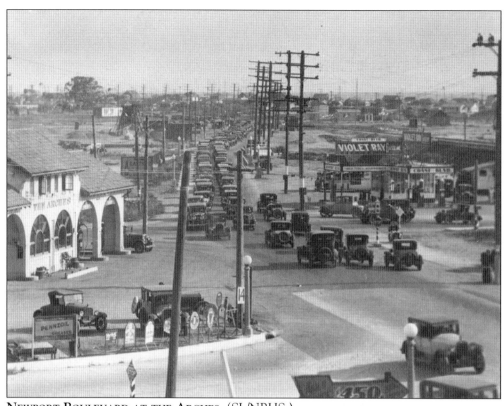

NEWPORT BOULEVARD AT THE ARCHES. (SL/NBHS.)

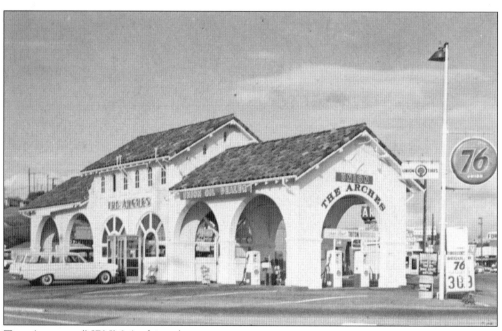

THE ARCHES. (NBNM Archives.)

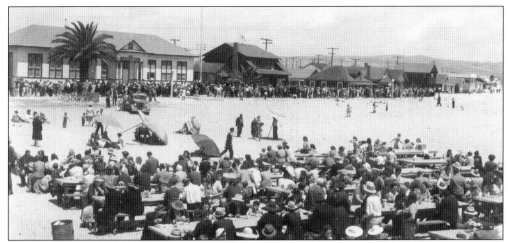

FISH FRY AT NEWPORT BEACH CITY HALL. Newport, Balboa, and West and East Newport were incorporated as the city of Newport Beach in 1906. The majority of Balboa Island was added in 1916, and Newport Heights was annexed the next year. The year 1924 marked Corona del Mar's entry to the town, but Balboa Island held out till 1927. In 1943, Harbor Island joined the city. During the decade from 1947 until 1956, Newport grew to almost five times its original size with the addition of Harbor Heights, Shore Cliffs, Bay Shores, Balboa Coves, Irvine Terrace, Linda Isle, Corona Highlands, and Cliff Haven. The first city hall was located east of the Newport Pier. Originally constructed as the first elementary school (pictured), the wooden frame structure was built in 1905. In 1948, through shrewd negotiations with developers, a new tax-free city building, complete with fire station, was constructed between 32nd Street and Newport Boulevard. (NHNM.)

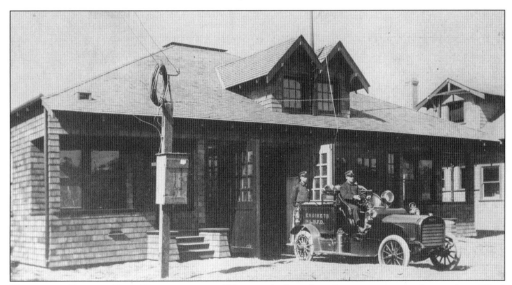

NEWPORT BEACH FIRE DEPARTMENT. The city's first fire department was located at 22nd Street in 1910. W.A. Cornelius, *Newport News* editor, was appointed as the first fire chief. Frank Crocker took over as chief in 1927, supervising the new firehouse at 703 East Bay. A second station opened at 2817 Newport Boulevard and the present facility at 475 32nd Street was opened in 1953. The Central Avenue (now Balboa Boulevard) and Balboa Island stations were constructed in 1931. (NBNM Archives.)

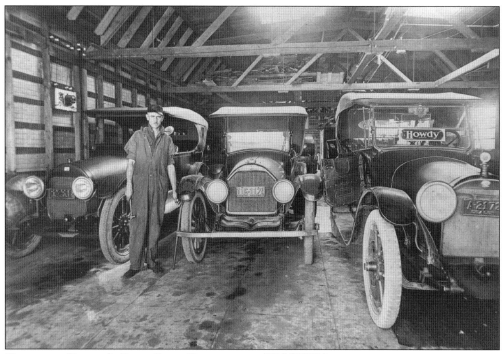

THEODORE ROBINS'S FIRST FORD DEALERSHIP. (SL/NBHS.)

1932 NEWPORT HARBOR HIGH SCHOOL YEARBOOK ADVERTISEMENT. (Newport Harbor High School/Heritage Hall Collection.)

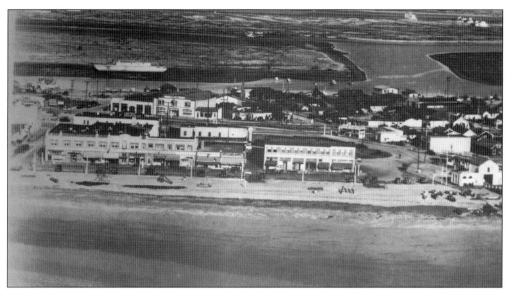

NEWPORT BEACH, C. 1930. (NHNM Archives.)

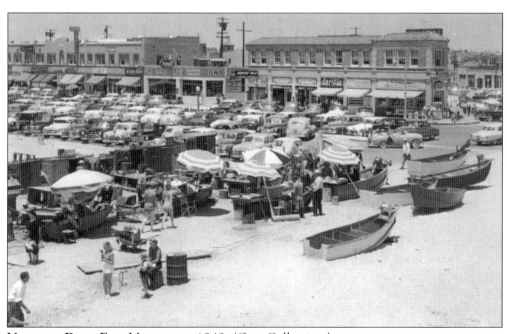

NEWPORT DORY FISH MARKET, C. 1949. (Gray Collection.)

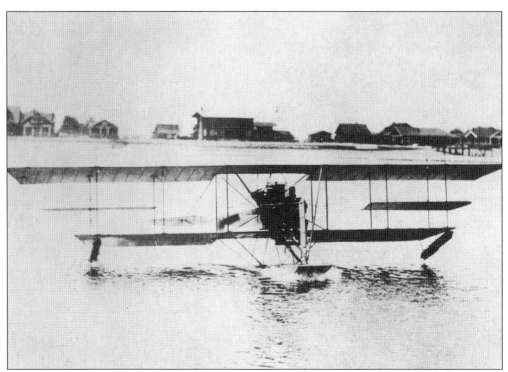

GLENN MARTIN. The longest over-water aviation record was made by Martin in his "Aero-Hydroplane" when he flew from Newport to Catalina Island and back on May 10, 1912. (SL/NBHS.)

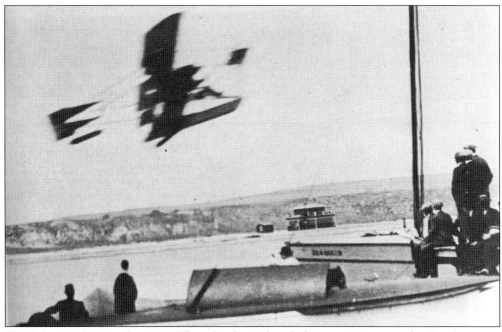

THE MARTIN FLYING SCHOOL. The school was founded in a tent next to the East Newport Pavilion by Glenn Martin. (NHNM Archives.)

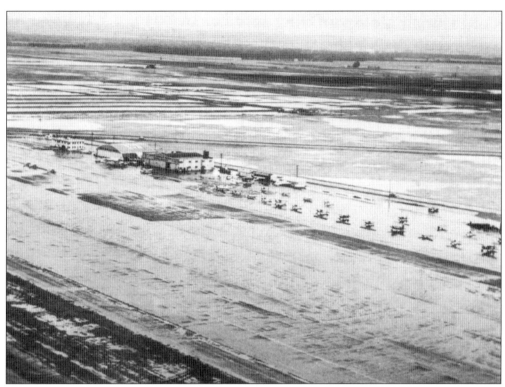

THE FUTURE ORANGE COUNTY/JOHN WAYNE AIRPORT. Drainage problems and flooding were frequent before county-wide flood channels were established after World War II. (NHNM Archives.)

MRS. HENRY SEIDEL, 1920. Seidel moved to Balboa to take lessons at Martin's flight school. She was motivated to learn after overhearing a conversation that held that women would never be able to fly. (NHNM Archives.)

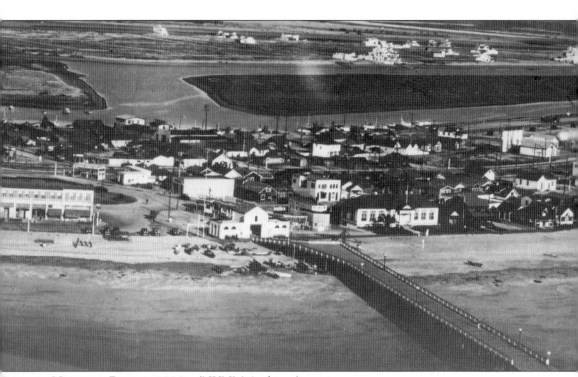

NEWPORT PIER, C. 1930S. (NHNM Archives)

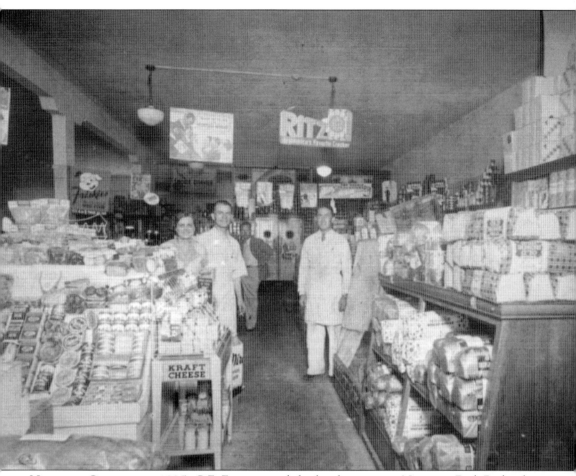

NEWPORT GROCERY C. 1935. C.F. Foy operated the local grocery in Newport. Dick Richard joined Foy as an assistant in 1935, before managing the Lido Market. (California State University, Fullerton Public and Oral History Collection.)

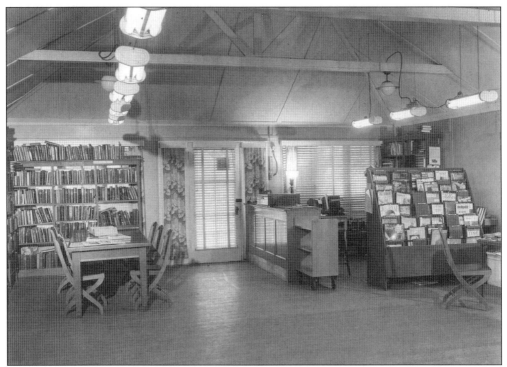

NEWPORT LIBRARY, APRIL 5, 1920. The Ebell Club of Newport Beach was established on October 18, 1909. One club project included the creation of a lending library on April 5, 1920 (a board of library trustees was created the following month). The clubhouse served as a temporary location until the 1,100-book collection could be placed in the first city library. (SL/NBHS.)

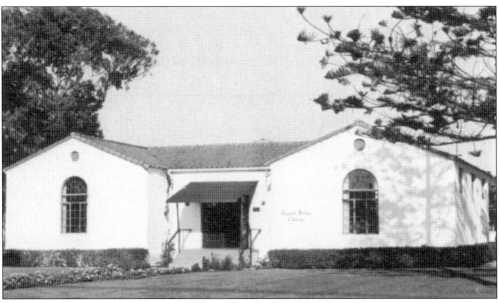

NEWPORT LIBRARY, C. 1929. The first official library building was dedicated on May 30, 1929, in East Newport Park. (SL/NBHS.)

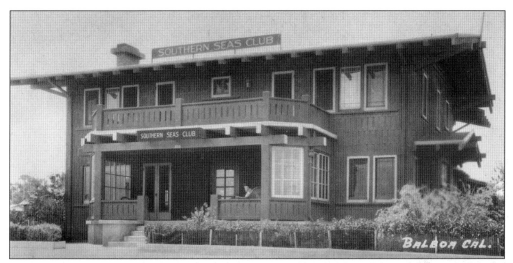

THE SOUTHERN SEAS CLUB AND CHRISTIAN'S HUT. The Southern Seas Club operated as the official sales office for Lido Island land sales in 1930. The club was later converted into the Palisades Restaurant. By the 1930s, the structure, draped with netting and with an added dock entrance, became Christian's Hut. Art LaShelle opened the Tahitian-style bay front restaurant featuring a barbeque pit in front of the structure that was used to prepare lunch and dinner fare. The sand-floored ground level bar was a favorite of Howard Hughes, Fred MacMurray, and Humphrey Bogart. The structure burned in 1963, and Newport Towers occupies the site today. (NBNM Archives.)

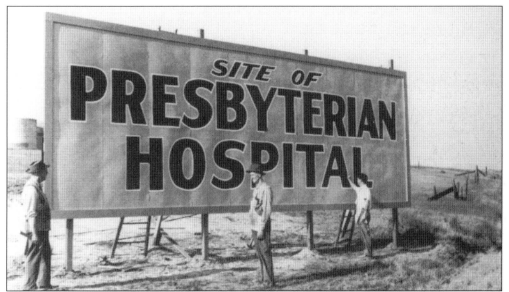

HOAG MEMORIAL PRESBYTERIAN HOSPITAL. Newport's first resident doctors were Conrad Richter and Gordon M. Grundy. Grundy opened the city hospital at the intersection of Central Avenue (now Balboa Boulevard) and Ninth Street. The George Hoag Family Foundation in cooperation with the Association of Presbyterian Ministers and a group of local residents and physicians were responsible for the hospital founding in 1950. Even though the land was not officially within the city limits, the fundraisers at the Balboa Bay Club were instrumental in providing building funds. (NBNM Archives.)

NEWPORT HARBOR HIGH SCHOOL, 1930. The high school opened in September 1930, after a whirlwind building effort. The gym and other finishing details would be completed during the spring semester. With over 200 students and two dozen faculty members, the "Sailors" would wait until 1932 to graduate the first seniors. (Newport Harbor High School/Heritage Hall Collection.)

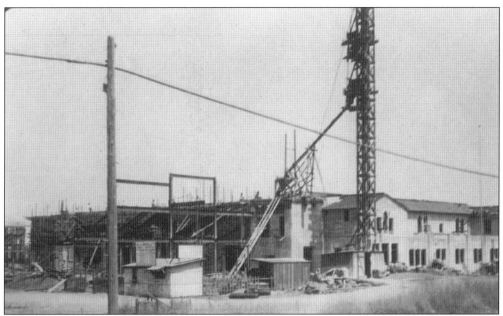

NEWPORT HARBOR HIGH SCHOOL CONSTRUCTION. Following more than a half-decade of lobbying efforts to create a new district, and a few months of construction, Newport Harbor High School later expanded with halls named for Judge Donald Dodge, Joseph Beek, and popular local English teacher James Sims. The first female students were required to wear white blouses with nautical trim and navy blue skirts. Sports teams played at Davidson Field, named to honor the first principal. (NHHS Heritage Hall Collection.)

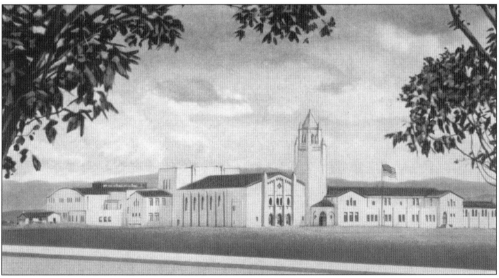

NEWPORT HIGH SCHOOL. The tower at Newport High School can be seen throughout the area. The tower was fitted with a bell after a student trip to Mexico. The mosaic murals in the quad were completed as a Work Progress Administration art project. The Heritage Hall Museum and display, curated by former math teacher Webster Jones, presents the history of the school through a collection of yearbooks, photographs, architectural elements (from the remodeled auditorium), and other memorabilia. (Sherman Library.)

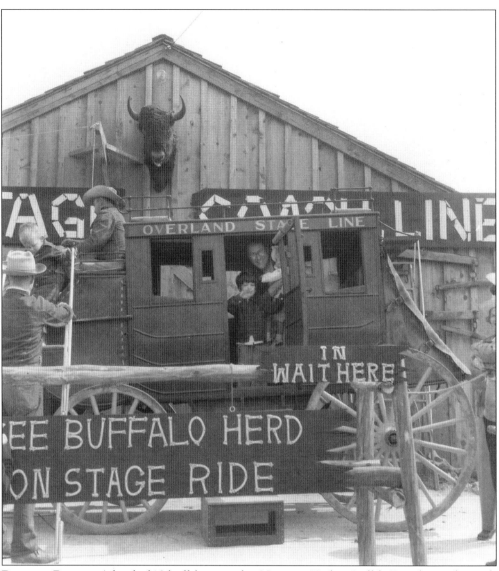

BUFFALO RANCH. A herd of 12 buffalo arrived at Newport Harbor Buffalo Ranch, a mile north of Coast Highway on the east side of MacArthur Boulevard, in June 1955. The 115-acre ranch was leased from the Irvine Company by Gene Clark, who had trucked the herd from Kansas. News reports claimed that Clark was planning to add four Native American families to perform dances and live in a traditional manner, but no record exists to indicate that they ever arrived. A small carnival-type miniature tractor ride and Western souvenir store were opened at the site. By the 1970s, the buffalo were gone, but the ranch house remained, disappearing with later residential development. (SL/ NHNM.)

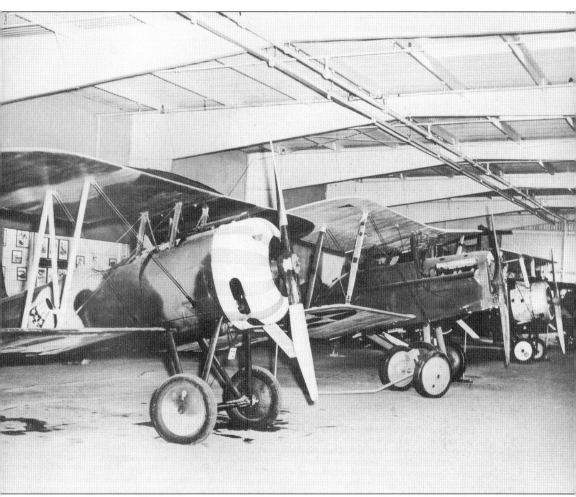

MOVIELAND OF THE AIR. Paul Mantz, a trial pilot, racer, and Colonel in the Special Service Motion Picture Division during World War II, teamed with Frank Tallman, another popular movie pilot, to create Tallmantz Aviation at the Santa Ana Airport. Their working aircraft fleet was responsible for flight sequences seen in *Air Mail* (1932), *Twelve O'Clock High* (1949), *The Spirit of Saint Louis* (1957), and numerous other features, serials, and short subjects. Mantz was killed while filming *Flight of the Phoenix*. Tallman continued to serve as film stunt coordinator until his death in 1978. Retired Air Force Major James S. Appleby, with restoration partner Zona Appleby, opened the Movieland of the Air Museum at the Orange County Airport. James served as curator until the museum was relocated during the airport expansion. (NHNM Archives.)

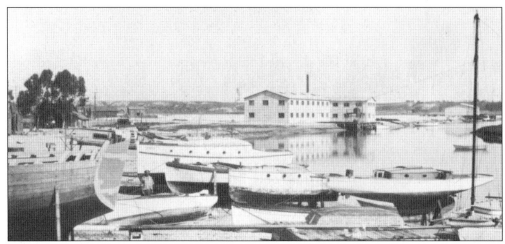

BALBOA PACKING COMPANY, C. 1919. The cannery was constructed in 1919 on "the Rhine" at 28th Street. After canning fish and then shifting to manufacturing fish fertilizer, it ceased operations in 1921, but reopened in 1929 to can sardines and, later, tuna. After the Cooper Wholesale Fish Market operated the building for some years, Walter M. Longmoor took over. Longmoor came to Newport in 1935 to operate the Balboa Packing Company, which was experiencing financial difficulties. Longmoor had purchased the Curtis Company of Bloomington (near Riverside) in 1934 after working there for 18 years. He continued to pack mackerel under the Curtis label until his preprinted label supply was exhausted. (SL.)

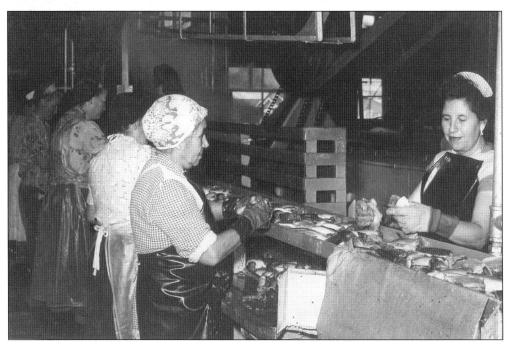

INSPECTING FISH, WESTERN CANNERS, C. 1940. Newport Beach had three canning plants that packed fish caught mainly in Catalina, Santa Cruz, and the Santa Monica Bay. Western Canning depended on nearly 50 scoop boats (as opposed to sein or net boats) that used only two men to fish. Before refrigeration, canning employees frequently would work 17- to 19-hour shifts. Many fishermen's wives and daughters were employed at the plant. (CSUF.)

WESTERN CANNING. Thomas came to work for Longmoor in 1936 and became his partner in Western Canning. The plant expanded in 1938 and again in 1955, when they purchased Van Camp's West Coast Corporation next door. The company converted to producing pet food by 1960 and closed in 1969. The Cannery Restaurant operates today at the site in the 30th Street Turning Basin. (CSUF.)

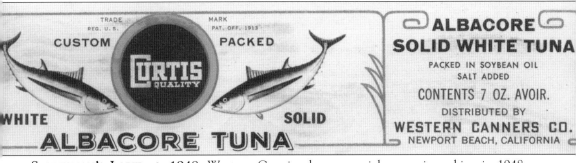

SPORTSMAN'S LABEL, C. 1948. Western Canning began special souvenir packing in 1948. They were alone in this operation until 1960. Fisherman would receive one can for a pound of fish delivered "in the round" (or whole). The fishermen were charged a service fee per can, but were able to personalize their canned catch to give to friends and family. (CSUF.)

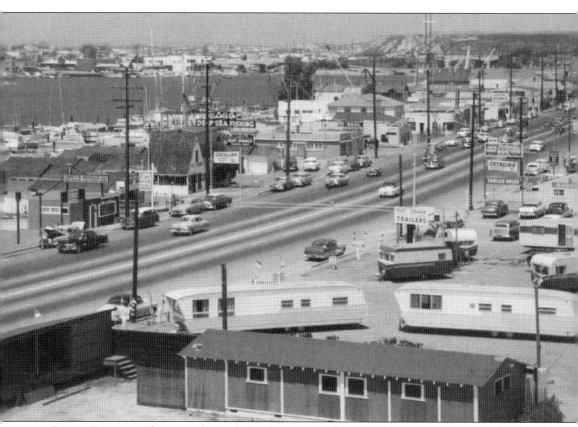

PORT ORANGE. The port, located on the site of the old Newport Landing, had a small sidewheel excursion boat that toured land investors over sandbars and marshes. Port Orange would later be developed as a sport fishing landing. King's Landing (on the Lido Peninsula), Balboa Pavilion, Port Orange, Scott's Landing, Earl's Landing (on Coast Highway), Art's Landing, Newport Pier, and Davey's Locker and Newport Landing remain in operation today. Restaurants and high-rise apartments now occupy the sites of the former landings. The Sports Fishing Association of Newport Harbor was established in the 1950s. (NHNM Archives.)

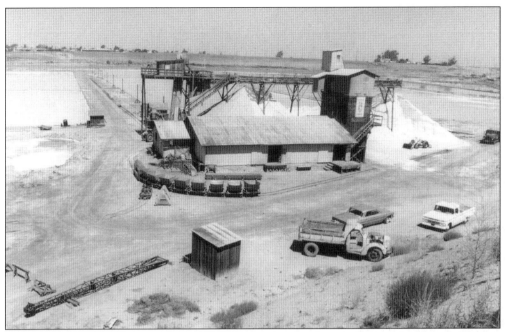

SALTWORKS, UPPER BAY, C. 1940. Operated by the Irvine Company, the works were established in the mid-1930s. After disastrous floods in 1968 destroyed the solar evaporation area, the company deemed the works a total loss and abandoned operations. (NBNM Archives.)

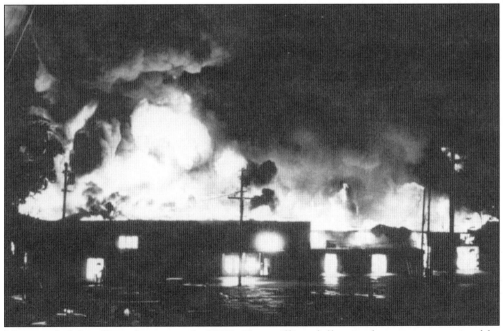

MARINER'S MILE FIRE, JANUARY 1, 1975. Two million dollars in damage was sustained by structures located on Pacific Coast Highway between Tustin and Riverside Avenues in the worst fires in the city's history. The entire block on Mariner's Mile was declared a loss by insurers. (NHNM Archives.)

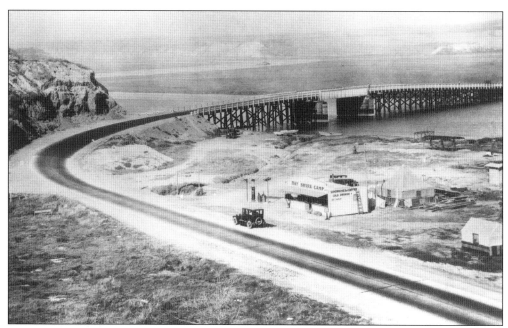

BAYSHORE CAMPING, C. 1922. (NHNM Archives.)

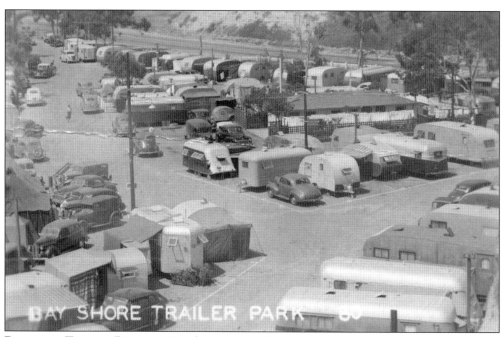

BAYSHORE TRAILER PARK, 1950S. (NHNM Archives.)

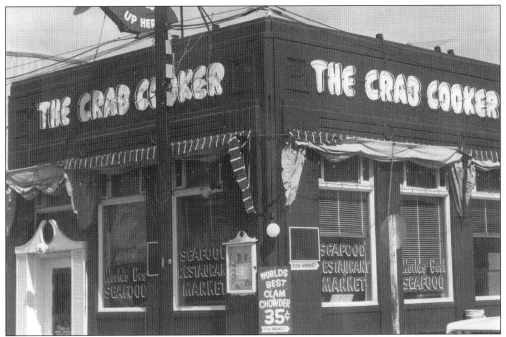

THE CRAB COOKER RESTAURANT, "CHOWDER 35¢," C. 1968. This landmark was established on the Balboa Peninsula in 1951. The 1,700-square-foot restaurant and the 9,000-square-foot annex across the street serve over 2,000 diners on a summer Saturday, with a wait of over two hours. The Crab Cooker was a favorite of President Richard Nixon. Local lore has it that he was denied reservations and was made to wait in line with other diners. (Photograph Courtesy Robert Roubian.)

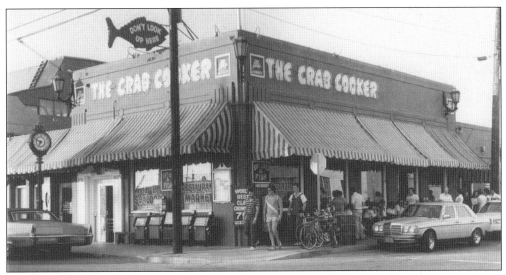

CRAB COOKER, "CHOWDER 75¢." Bob Roubian, proprietor of the Crab Cooker, is a sculptor, musician, and art collector. His dining philosophy is simple: "The only way that health begins—Eat the food that comes with fins." Specialties include clam chowder, home-baked breads and, of course, seafood: crab, lobster, halibut, salmon, and channel white sea bass. (Photograph Courtesy Robert Roubian.)

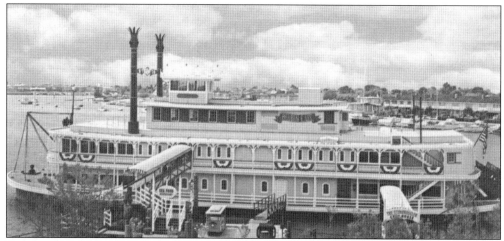

REUBEN E. LEE, C. 1962 (THE PRIDE OF NEWPORT). Designed by Newport architect William Blurock, the restaurant was housed in a double-decked Mississippi sternwheeler paddle boat. Far West Services, a division of W.R. Grace Company, purchased the restaurant in the 1970s. The former *Reuben E. Lee* has been transformed into *The Pride of Newport* to house the Newport Harbor Maritime Museum at 151 East Coast Highway. The museum was relocated in 1986 under the guidance of Bettina Bents. Historical displays, models, and a nautical library and archives are located at the 900-ton site. An adjacent aquarium and a Harbor Patrol fireboat are used in educational programs at the Museum. (Gray Collection.)

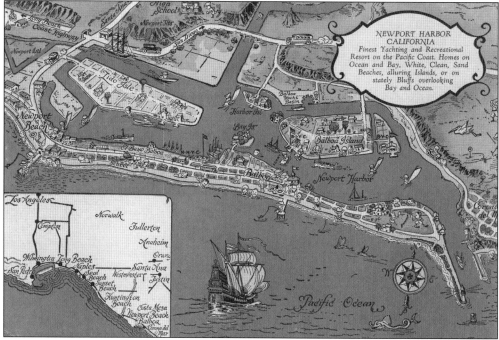

SPORT FISHING MAP, C. 1950S. Produced by the Newport Harbor Sport Fishing Association, this map shows 27 landings, 10 daily live bait boats, 32 trolling boats, and one live bait barge all operating in the harbor. (NHNM Archives.)

THE NEWPORTER INN. Built overlooking Balboa Bay by George D. Buccola Enterprises in 1961, the original hotel included 115 rooms surrounded by a Par 3 golf course and two swimming pools. Five settings for dining were available for lunch and dinner, and a banquet room could seat 400 people. Guests could reach the hotel by limousine service and daily helicopter flights from Los Angeles International Airport. Don Daley was the hotel's first manager. Known as Del Webb's Newporter after a sale in the 1970s, the hotel changed hands several times in the 1980s, and was demolished in the 1990s to make room for residential housing. (Gray Collection.)

THE NEWPORTER INN. The Inn was the only major construction project on Jamboree Boulevard in 1961. (NBNM Archives.)

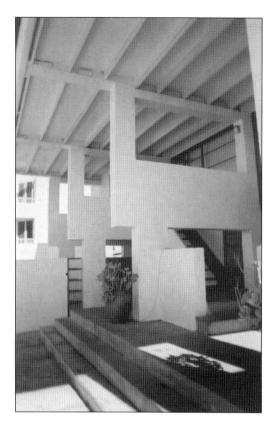

THE LOVELL HOUSE, NEWPORT BEACH, 2003. Noted architect Rudolf Schindler, one-time assistant to Frank Lloyd Wright, designed this Ocean Avenue home for Dr. Philip Lovell. One of the first pure "International Style" houses built in the United States, the 1926 home incorporates cast concrete frame and wood. Other special features designed for healthy living include large windows for fresh air and sunshine. (Gray Collection.)

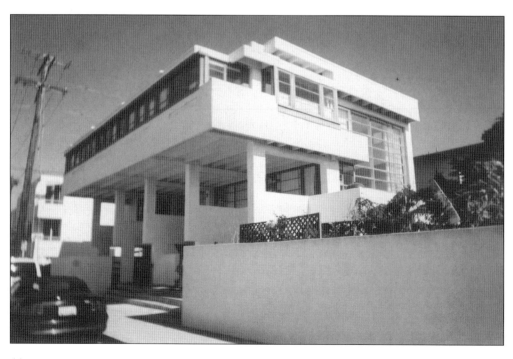

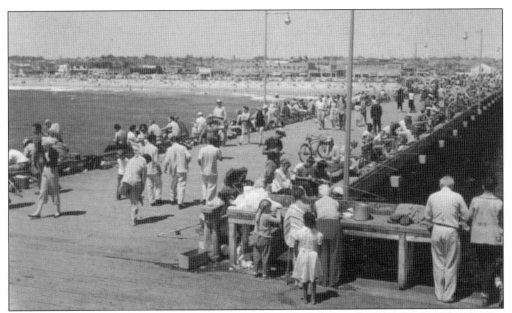

NEWPORT PIER, C. 1940. The city of Newport purchased the pier in 1922 for $5,000. The rebuilding, including restructuring the base and removing the railroad tracks, cost an additional $30,000. J.K. Smith and C.E. McFarland leased the pier for fishing operations in 1923. (Gray Collection.)

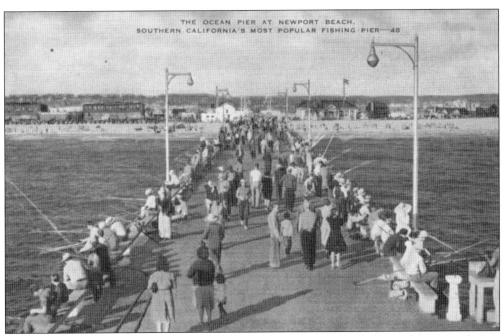

FISHING AT NEWPORT PIER C. 1947. A municipal pier was created at McFadden's Landing in 1906 after the city was incorporated. In 1922, the structure was remodeled to include traffic lanes. The pier was destroyed in the disastrous storms of 1939, but rebuilt the following year. Storms since the 1980s have done damage to parts of the structure, and another major remodeling took place in the 1990s. (Gray Collection.)

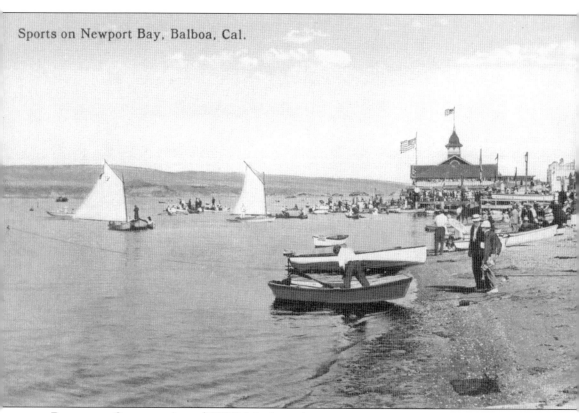

BALBOA, A CENTURY AGO. (NHNM Archives.)

Two
BALBOA

The Abbott Family moved to California from Iowa in 1880. Nine years later Edward Abbott built a small cottage at present-day Bay Avenue and Palm Street. This early home, some say the first built in Balboa, was located near the only freshwater spring on the peninsula. Abbott was an entrepreneur who subdivided lots for real estate sales and conceived a plan for the transportation of fresh water to nearby Rocky Point (now Corona del Mar). The Abbott family's seashell sales were popular and fondly remembered for decades. Abbott's steam excursion boat the *Last Chance* used the small landing he constructed near the current ferry landing. Early visitors to Rocky Point had rowed their own canoes in to picnic, swim, or climb rocks, but the *Last Chance* became the perfect way to tour the area or visit Rocky Point. Various accounts offer different explanations for the discontinuation of the steamboat: failure to obtain a state license or pilot license, or a lack of ridership to make the service profitable. Whatever the reason, the *Last Chance* was relocated with difficulty to Lake Elsinore. Abbott died in 1895, leaving his holdings to his brother-in-law and sometime partner Clinton Andre. Andre subdivided the land and offered lots for several hundred dollars each, although few people bought houses in Balboa at first.

Wild ducks and clams by the bucketful made the Balboa area a favorite spot for outdoor sport enthusiasts. Balboa began as Bayside, a group of wooden summer cottages built next to Abbott's Landing. Growth would be directly tied to the arrival of the Pacific Electric Red Car in 1905. The Newport Bay Investment Company purchased land from Joseph Ferguson and, through 1904 and 1905, J.P. Greeley and F.W. Harding worked frantically to construct cottages and a large pavilion in time for the arrival of the electric trolley line. E.J. Louis, another company shareholder, is given credit for naming the village after the famous explorer.

The Abbotts, Soilands, Tullys, Beeks, and a handful of other families were early residents and Balboa promoters. W.S. Collins, another early developer, opened Collins' Commercial Company, a machine shop that built boats and a dredging machine that would aid in area development. Collins built his own home and dredged sand to shape Balboa Island. Early parades and picnics failed to attract residents, however, and economic depressions stalled area development. Trash covered the vacant lots, exposed pipes belched sewer water, and the seawall continued to sink into the bay.

Even if Balboa had trouble attracting year-round residents, the area did have scores of visitors on weekends and holidays. The Balboa Pavilion attracted thousands of visitors who rode the Red Cars into town for a day, or weekend, of swimming, sun, sailing, and amusements. A ferris wheel, gaming, and restaurants drew tourists to Balboa. The Fun Zone created in the 1930s offered arcade games and rental canoes, sailboats and, later, speedboats. After remodeling in the 1970s and again in the 1980s, the area continues to offer rides, amusements, and entertainment. Sport fishing businesses developed after World War II, and continue to thrive today. Balboa saw large-scale expansion as a residential community after 1945, and today is considered to be prime California real estate. The sun, sand, and ocean that attracted early settlers continue to lure visitors and new residents today.

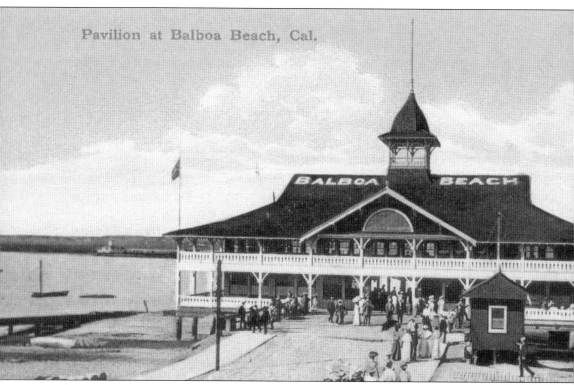

THE BALBOA PAVILION. W.S. Collins and A.C. Hanson purchased the town site of Newport Village and almost one-half of the Balboa Peninsula for nearly $35,000 in 1902. These 980-odd acres would later become the towns of Newport and Balboa and the islands of Harbor, Balboa, and Lido. Chris MacNeil constructed the pavilion for the Newport Bay Investment Company. Restaurants, sports fishing, offices, an art museum, gambling and card parlors, and bowling alleys have occupied the building since its opening in 1905. (Sherman Library.)

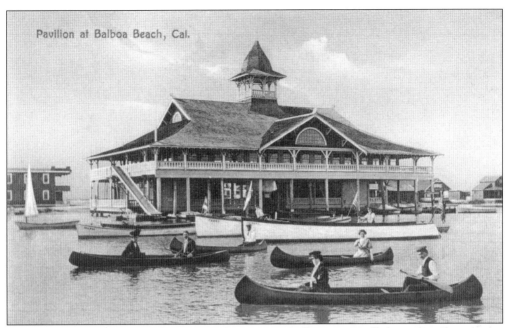

BALBOA, C. 1910. A popular tourist destination, Balboa was well-documented in penny postcards. Canoeing was a sport enjoyed by both men and women. (Gray Collection.)

CANOES AT BALBOA. (Sherman Library.)

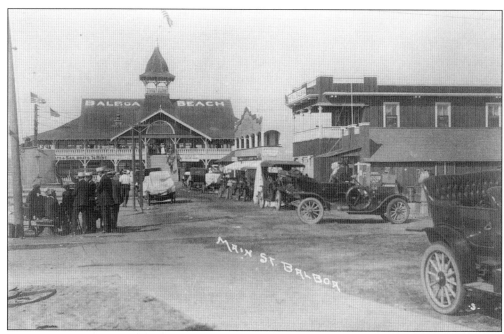

BALBOA HOTEL. A 15-room hotel was constructed in ten days, just in time for the July 4, 1906, arrival of the Pacific Electric "Red Car." (First American Financial Corporation Archives.)

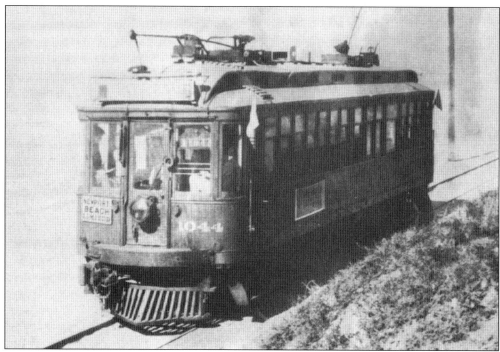

PACIFIC ELECTRIC CAR. An excursion train in the late 1940s recreates the turn of the century ride of the Pacific Electric route to Balboa. (SL/NBHS.)

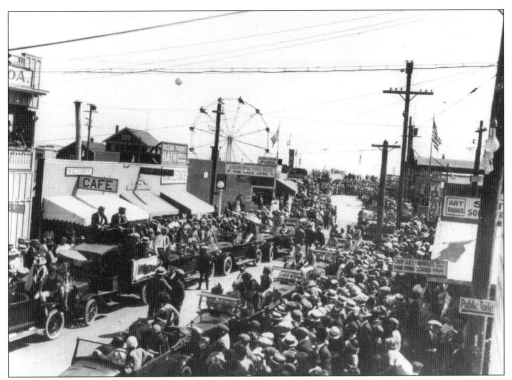

BUSTLING BALBOA, C. 1920S. (NHNM Archives.)

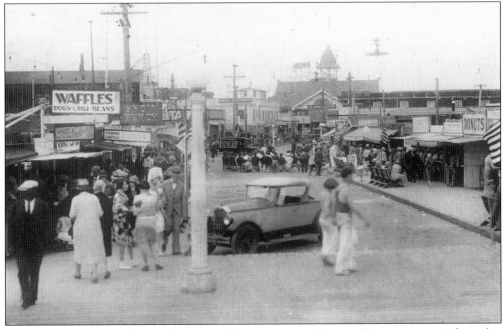

BALBOA PIER SUMMER BAND CONCERT. (First American Financial Corporation Archives.)

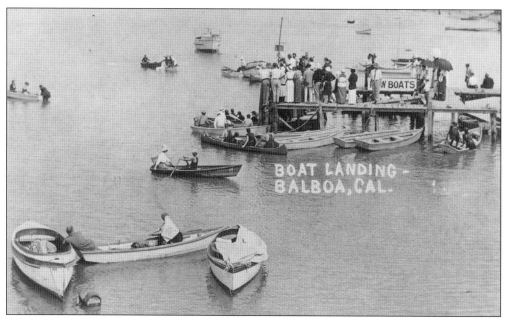

BALBOA ANGLING CLUB. Established in 1926, the club held meetings in the Balboa Pavilion until they moved into a room on Palm Street near the ferry landing in February of 1931. After World War II, the club constructed a dock, clubhouse, and weighing station at the foot of "A" Street. The first official municipal weighing station was located at the foot of Washington Street in Balboa, next door to the harbormaster's office. It was there that keepsake photographs of prize catches were taken. (NHNM Archives.)

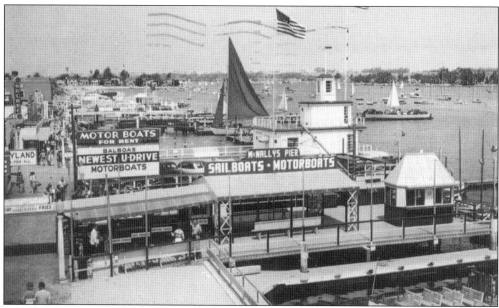

MCNALLY'S PIER. T.B. McNally ran fishing boats from Balboa in the 1920s and 1930s. The *Daisy*, *Dixie*, *Dandy*, and *Dundee* fishing fleet trolled for calico bass, bonito, yellowtail, and barracuda. Fishing by trolling was well-established before live-bait fishing. McNally was a founding member of the Balboa Angling Club and an activist for ocean kelp-bed preservation. (Gray Collection.)

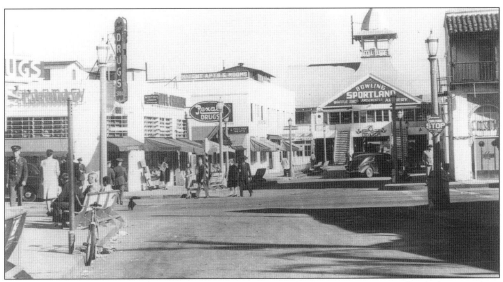

DOWNTOWN BALBOA, C. 1944. (First American Financial Corporation Archives.)

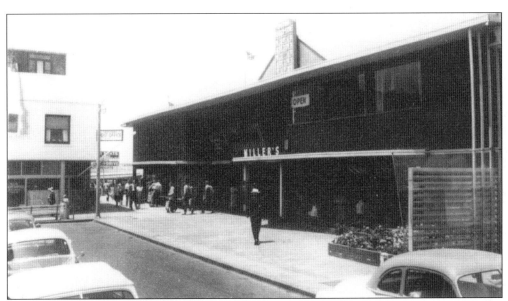

MILLER'S STORE. The Balboa Pavilion underwent a series of transformations after its construction in 1905. Bathing pavilion, dance hall, bowling alley, gaming parlor, and restaurant were just a few of the building's uses. The balconies were covered when the structure was remodeled as a department store. The Gronsky Family helped organize the renovations which returned the pavilion to its early elegance. (Joe Tunstall Collection.)

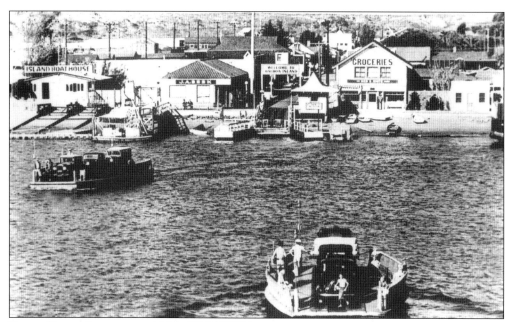

EARLY FERRY SERVICE, C. 1920. (SL/NBHS.)

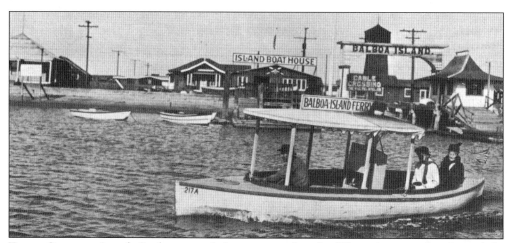

FERRY SERVICE. Joseph Beek operated the converted yacht *Where Away* as the *Around the Island Ferry*. It was used as a water taxi where riders could hail the service and be delivered to a requested location. The service was discontinued in the 1950s. (SL/NBHS.)

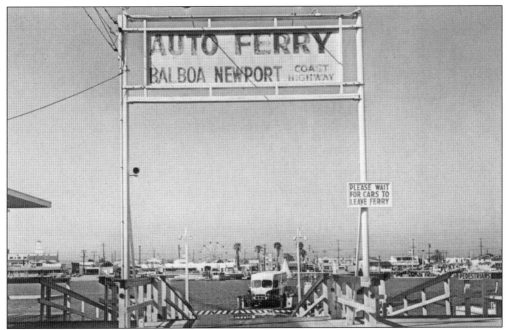

Ferry Service, c. 1950s. The *Admiral*, *Commodore*, and *Captain* ferry passengers and autos from Balboa to Balboa Island. The current boats went into service in the 1950s. The Beek Family still owns the operation, which is the second oldest continuing operating ferry in the United States. (First American Financial Corporation.)

The U-Drive Sign. The sign has become a landmark. In 1992, it was rediscovered in storage and repaired by neon artist Steve Murad, and the painting restored by Debra Huse. The sign was dedicated in 1999. (Gray Collection.)

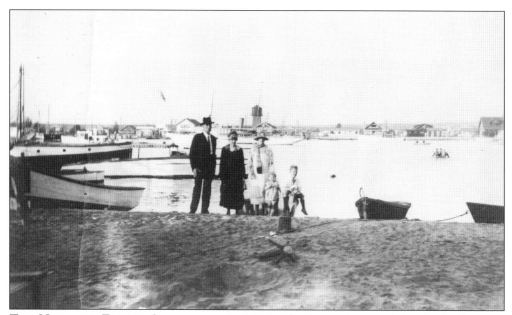

THE NEIGHBOR FAMILY, SEPTEMBER 24, 1925. The large water tank in the background supplied fresh water for Balboa Island. (NHNM Archives.)

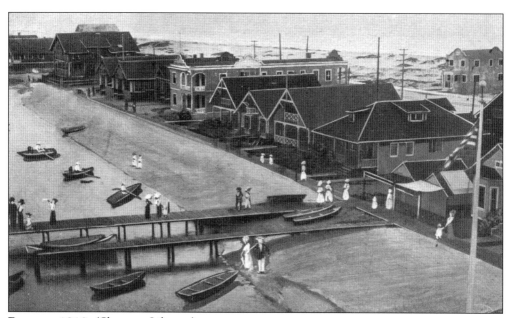

BALBOA, 1910. (Sherman Library.)

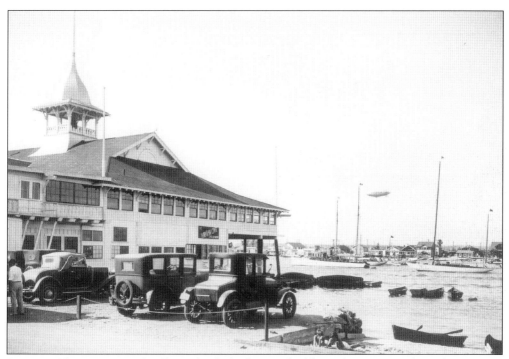

BALBOA. This is a view of Balboa Island, the bay, and a blimp. (NHNM Archives.)

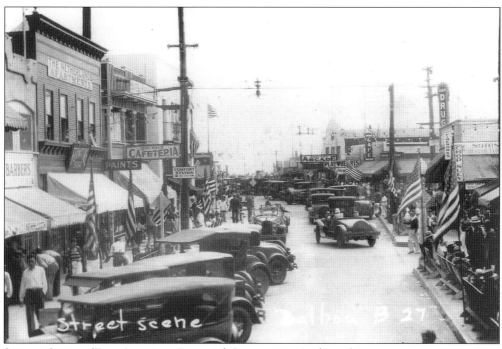

STREET SCENE. (First American Financial Corporation Archives.)

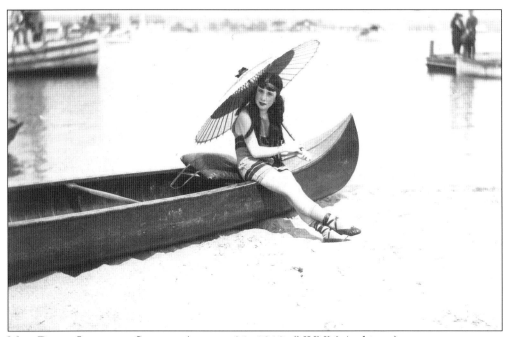
Miss Dolly Lorraine Simons, August 31, 1919. (NHNM Archives.)

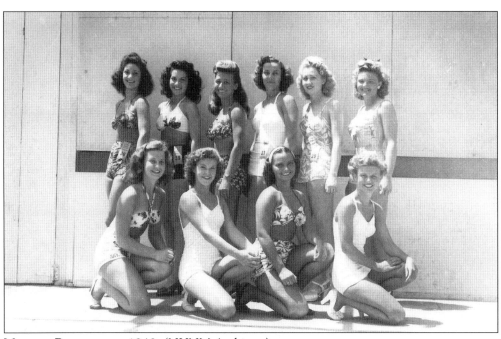
Modern Beauties, c. 1940. (NHNM Archives.)

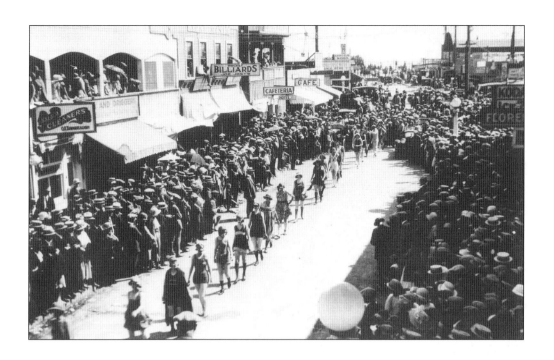

BEAUTY CONTESTS, C. 1920. (NHNM Archives.)

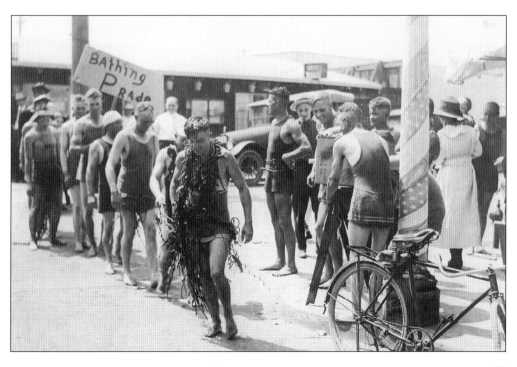

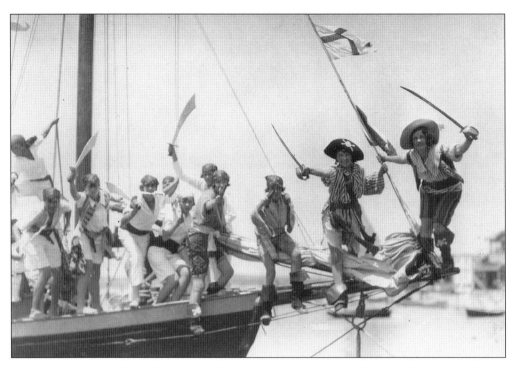

PIRATE DAYS. Joseph Beek was the ultimate promoter. To recall an earlier movie shot in Balboa, Beek organized *Pirate Days* to promote Balboa. The Junior Chamber of Commerce sponsored the event. (NHNM Archives.)

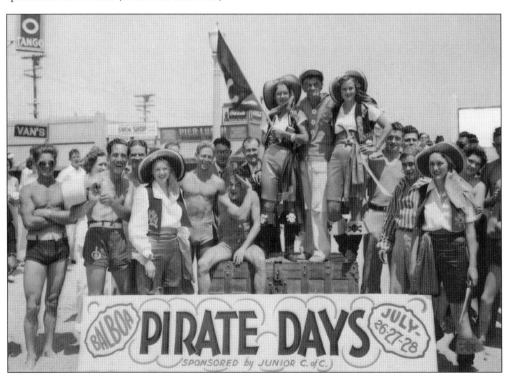

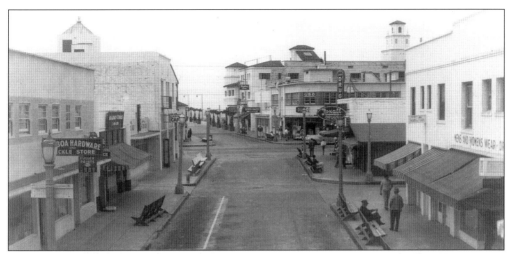

DOWNTOWN BALBOA, C. 1940S. (First American Financial Corporation Archives.)

THE CURIO SHOP, 1932. Open until the 1960s, the shop was a well-known tourist attraction. (NHHS/Heritage Hall.)

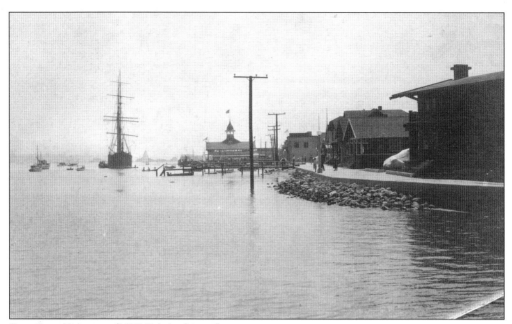
Bay Side Balboa. (NHNM Archives.)

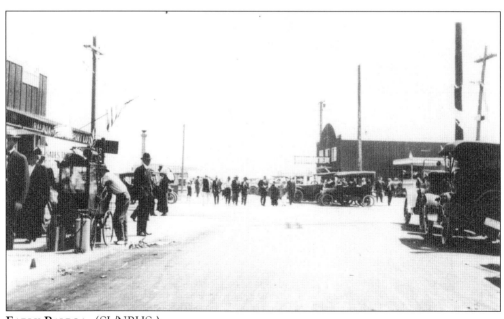
Early Balboa. (SL/NBHS.)

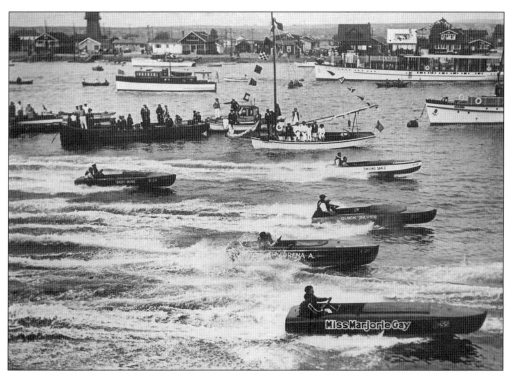

SPEEDBOATS. Early boats included W.S. Collins hydroplane boats purchased in 1910. Collins' Commercial Company constructed a motor cruiser in 1915 that would become the fastest boat on the bay. Before maritime regulations limited speeds in the bay, speedboats including the *Quick Silver* and the *Miss Marjorie Gay* (pictured) would race into the harbor. Sirens would sound to warn swimmers and boaters of the potential for collision. Tourists and residents would come out to watch the boats fly by. (NHNM Archives)

BALBOA CASINO, C. 1930S. Punch boards, slot machines, and games of chance were offered in Balboa until the county administration changed after World War II. (NHNM Archives)

THE RENDEZVOUS BALLROOM. The Ballroom was built in 1928 as a small dance venue to compete with the Balboa Pavilion. By 1935, all the major headliners played the Ballroom: Glenn Miller, Stan Kenton, Gil Evans, and the Dorseys. Admission was 50¢. The dance-floor arrangement had dancers enter the floor with a five cent dance ticket, or purchase a lounge ticket for about one dollar that would allow them the option to stay on the floor after each dance or be seated to listen to the music. Nickel ticket holders had to purchase new tickets to return to the dance. (NHNM Archives.)

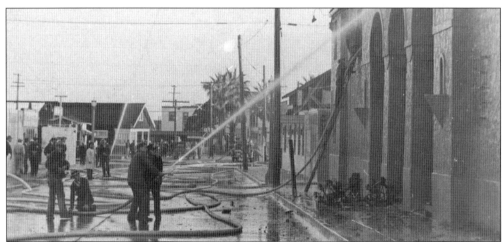

THE RENDEZVOUS BALLROOM, C. 1928. The ballroom was located between Washington and Palm Avenues, on the present-day Ocean Front Boulevard. Local musicians, Dick Dale and the Deltones, opened at the Rendezvous on July 1, 1961. From a dismal showing of only a handful of people, the crowds grew and yet another national dance craze, "The Surfer Stomp," was invented. The room continued as a dance venue until 1966, when the landmark burned down. Ironically, the Cindermen were the last to play the night of the fire. Reunions have taken place over the years. Big bands reprised their nights at the Newporter Hyatt and at the Balboa Pavilion, and the surf rockers have met since 2000 at the Galaxy Concert Theater. (NHNM Archives.)

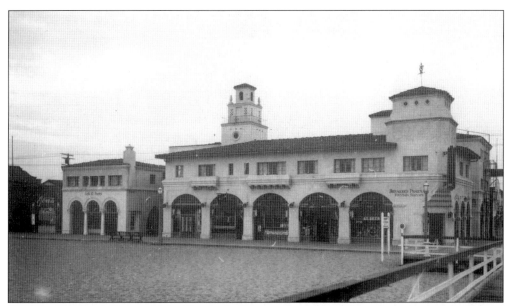

"DRUGLESS DRUG STORE." The Breaker's Pharmacy was located in the corner of the Balboa Insurance Building. During Prohibition the store purportedly sold alcohol at two bits per ounce, but carried few prescription drugs. (NHNM Archives.)

LOOKING DOWN MAIN STREET TOWARD THE PAVILION. Dick Vogel's real estate office can be seen on the right-hand side of the street at 100 Main. Vogel and Beek were instrumental in lot sales and building development in Balboa. Today the Studio Cafe is located on the site. The palm tree planters were a fixture from the 1950s through the 1960s. When the area near the pier underwent a renovation, the palms were planted in the park area. (Gray Collection.)

Some dumb guy was looking for the backbone of Harbor Hi Easter vacation.

BAL WEEK YEARBOOK CARTOON, 1932. Bal Week began in the 1920s as a high school, week-long celebration. Students enjoyed their holiday so much that other nearby schools, both high school and college, joined them for the festivities. The partying grew over the years to gain a national reputation. Law enforcement officials put a halt to the event in the late 1960s and again in the 1980s with tough enforcement of loitering laws, a new curfew, and an identification check to enter the peninsula by car. (Newport Harbor High School/Heritage Hall Collection.)

CELEBRATING BAL WEEK IN THE 1940S. (NHNM Archives.)

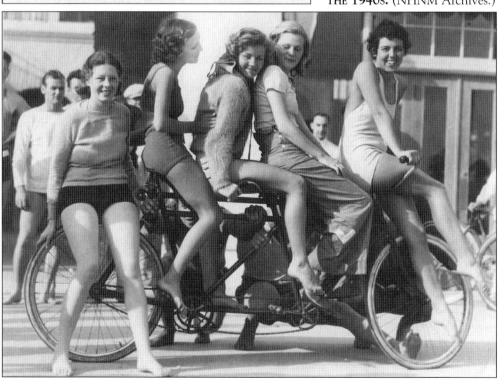

66

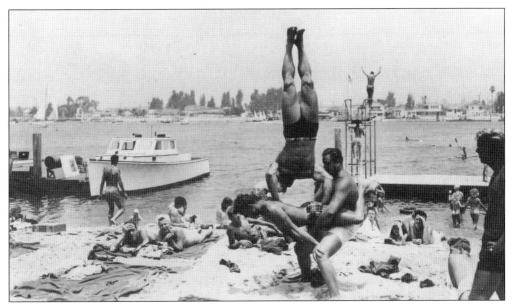

BAY SIDE BALBOA, C. 1948. Not to be outdone by Muscle Beach in Los Angeles County, Balboa had its own acrobatic displays and body builders. (NHNM Archives)

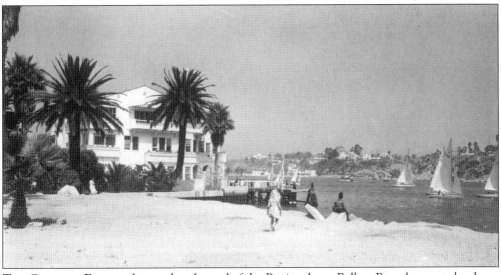

THE GILLETTE ESTATE. Located at the end of the Peninsula on Balboa Bay, the estate has been the subject of many stories about its remodeling. King Gillette, heir to a razor fortune, built the house in 1927, and only slept in the home once before selling it in the 1930s. Later owners extensively remodeled the structure, including a division of the house into two residences in the late 1930s. Musician Dick Dale owned the house in the 1970s and undertook several further renovation projects. (NHNM Archives)

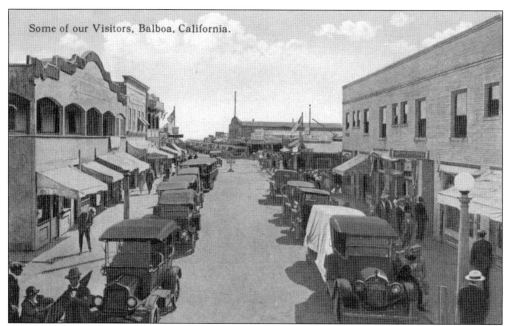

BALBOA, C. 1920. (NHNM Archives.)

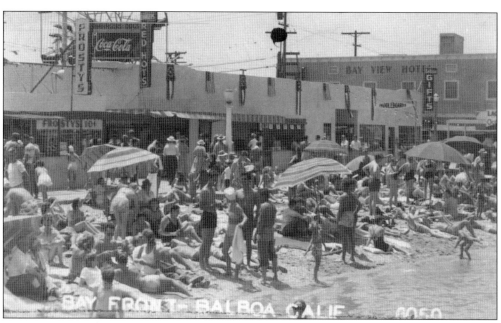

BALBOA, 1940s. (NHNM Archives.)

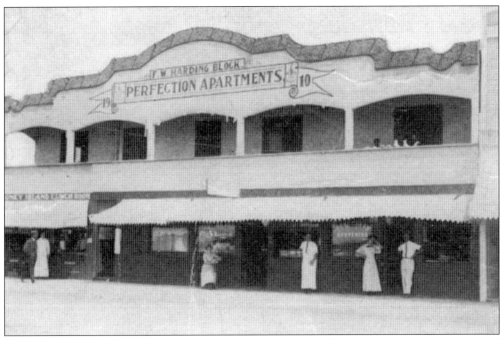

The Perfection Apartments, c. 1912. Some beach lovers built cottages, but most preferred to rent apartments or hotel rooms for their weekends and vacations. (SL.)

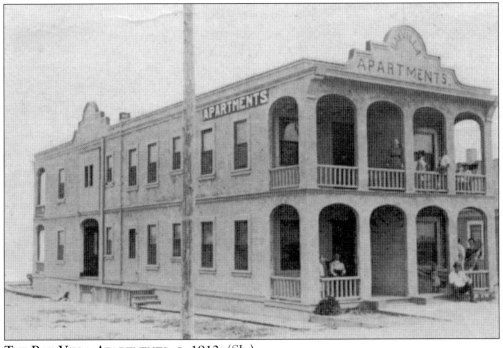

The Bay Villa Apartments, c. 1912. (SL.)

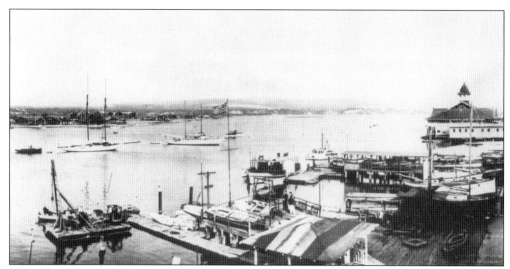
ROGERS BOATYARD AND LANDING AT BALBOA, SEPTEMBER 1917. (NHNM Archives.)

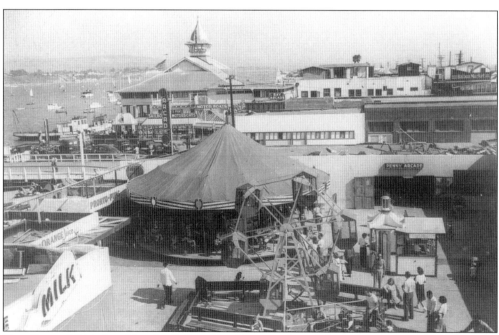
FUN ZONE, 1944. Land for the Balboa Fun Zone was leased from Fred Lewis by Al Anderson in 1936. Clearing vacant lots and remodeling buildings from shipyards for arcades, Anderson opened the Fun Zone midway through 1936, expanding the rides and games over the years to include bumper cars, a merry-go-round, and a Ferris wheel. (SL/NBHS.)

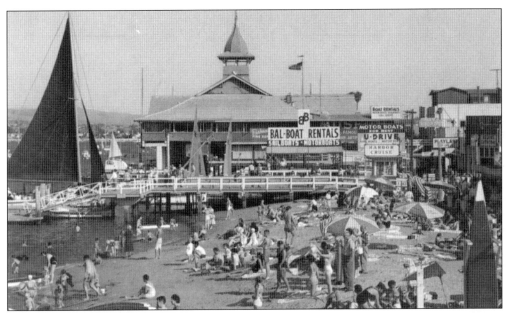

BALBOA IN THE 1940S. (Gray Collection.)

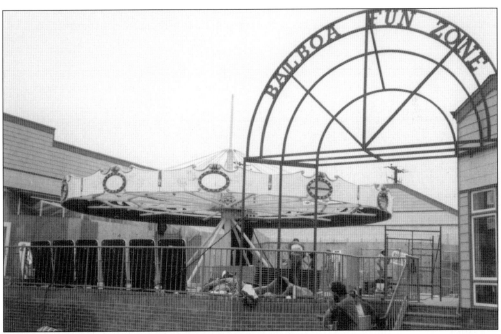

CONSTRUCTION ON THE NEW FUN ZONE. Joe Tunstall and Bob Speth had worked at the Fun Zone in their youth. They organized family members and friends to form a corporation to re-establish a new Fun Zone. The merry-go-round seen today, one of two company-owned carousels, was restored in 1986 after removal from a weed-choked field where it had been abandoned. Other historical additions include a "Laughing Lady" installed over the entrance to the Dark Ride. The original head and hand molds from the 1920s were manufactured by the Philadelphia Tobbogan Coaster Company, and were recast in 1988 to recreate the ominous greeter. (Joe Tunstall Collection.)

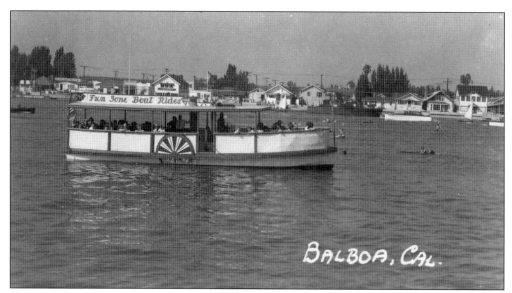

THE FUN ZONE BOAT COMPANY. The most popular of the three boats operating next to the ferry landing in 1947 were the two speedboats. The *Miss Balboa* and the *Leading Lady* were the highlights of intermissions of the Rendezvous Ballroom. Del Grettenberg purchased the company from Omar Closen in the late 1940s. Party and tour boats *Tiki*, *Showboat*, and *Queen* are operated today by Grettenberg's daughter and son-in-law, Dorothy and Ray Handy. (NHNM Archives.)

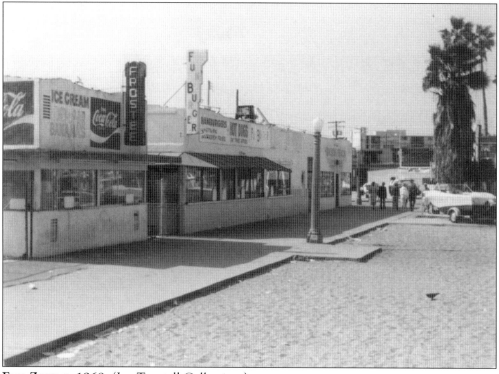

FUN ZONE C. 1968. (Joe Tunstall Collection.)

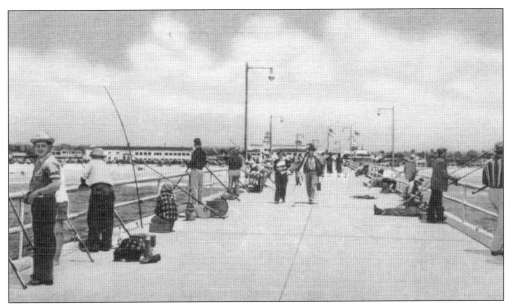

BALBOA PIER, 1939. (Gray Collection.)

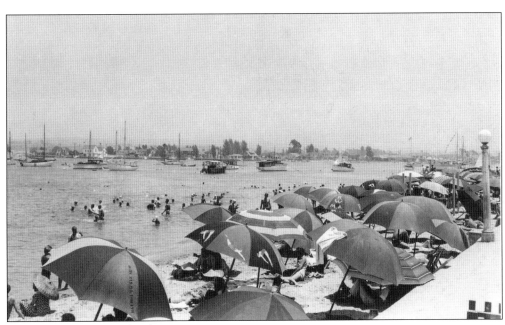

BALBOA BAY, 1950s. (SL.)

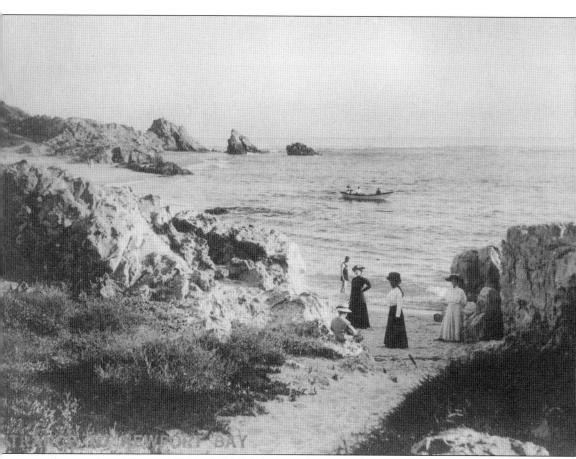
Corona del Mar, c. 1890. (NBMM Archives.)

Three
Corona del Mar

When the Irvine Ranch shifted from sheep and cattle grazing to agriculture in the 1880s and 1890s, James Irvine II decided to sell a portion of the Irvine Ranch to pay off debts incurred from a long-term drought. The acreage was purchased by Los Angeles real estate developer George E. Hart. Hart assumed that the newly developing areas of Newport, Balboa, Laguna, and San Juan-by-the-Sea (latter-day San Juan Capistrano) would provide a chain of beach towns that would attract tourists, as well as residents. The town was surveyed and subdivided by county surveyor Colonel S.H. Finley, and then graded. W.B. Artz of Tustin and C.S. Forgy of Santa Ana were selected as real estate agents for the project. Construction of an ocean-front pleasure pier began in July 1905, but it was still incomplete when a storm cut through a large section, requiring repair several months later. Another storm did further damage a year later. This pier stood until storms took down the remaining structure in 1912. A second bay-side pier was constructed to receive launches from the Balboa Pavilion where, after 1907, visitors could stay at the Hotel Del Mar.

The village had the ocean and bay on one side and pastoral views of the Irvine Ranch on the other three sides. This isolation proved to be an effective barrier to development. Until the highway was completed in 1926, the only way to reach the new village was by boat or by a rough, rutted road that wrapped along the bluffs around the Upper Bay (Back Bay Drive today). Hart quickly began laying out the plat map for the new town. The Crown of the Sea included today's "Old" Corona del Mar, Irvine Terrace, Promontory Point, Bayside tracts, and a portion of the Newport Dunes. The financial arrangements fell through when Hart's plan for quick sale were not realized immediately. He returned a portion of his original land purchase and made contractual agreements which would come back to haunt him before he resold his holdings.

Hart had designs for a full-scale resort at Corona del Mar, but these were never realized. Some historians speculate that failure to attract an electric streetcar line dampened Hart's enthusiasm. This undoubtedly reduced the income he had expected from his investment. His failure to meet the terms of his land agreement with the Irvine Company would spell his ultimate doom. The contracts for lots purchased by early residents wisely specified installment payments based on Hart's providing transportation into town, as well as provisions for water and a sewer supply. If these terms were not met, the buyers would not be required to make future payments. Hart decided in 1915 to abandon his investment. Some of the 2,300 lots were returned to the Irvine Company, and others were transferred to F.D. Cornell Company. It would take until well after World War II for the village of Corona del Mar to attract significant numbers of full-time residents.

During World War I, F.D. Cornell, a developer, thought land sales would improve by changing the name of the village to Balboa Palisades (emphasizing the proximity to nearby Balboa), but the residents would have no part of the new name. As they continued to use the original name, the new moniker gradually faded from memory. Electric Way (now the eastern portion of Bayside Drive), was changed after the trolley line failed to materialize. Corona del Mar today is known for its street names. "Old" Corona streets are arranged almost alphabetically by the names of trees and flowers. The spelling of Corona del Mar also changed in 1926 and again in 1950. Postcards from the 1920s spell Del with a capital "D," but in 1950, a second post office opened which officially used a lower case "d."

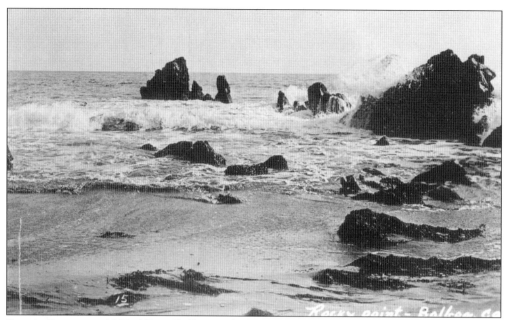

ROCKY POINT, C. 1900. (Gray Collection.)

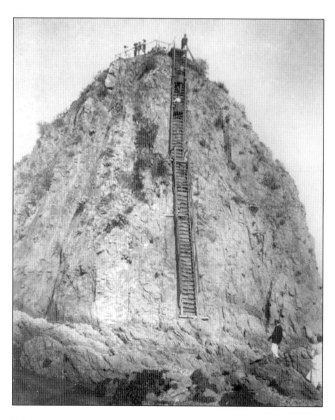

VIEW AT ROCKY POINT BY PIRATE'S COVE. (SL/NBHS.)

LUMBER DELIVERY, C. 1890. Stacks of lumber dry before their shipment inland in Orange County. Due to the difficult harbor entrance, the McFaddens would frequently unload lumber in the bay and float it inland. (NHNM Archives.)

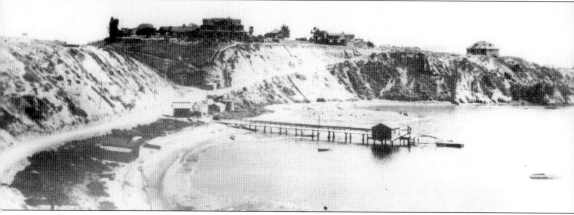

CORONA DEL MAR PIER, C. 1917. The fishing dock and landing were built for the Palisades Hotel. The pier was destroyed by storms in the 1920s. (NHNM Archives.)

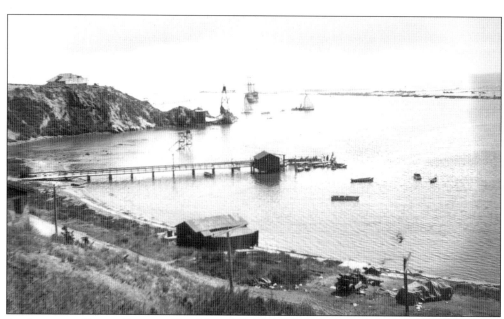

AN IMAGE OF EARLY CORONA DEL MAR. (SL/NBHS.)

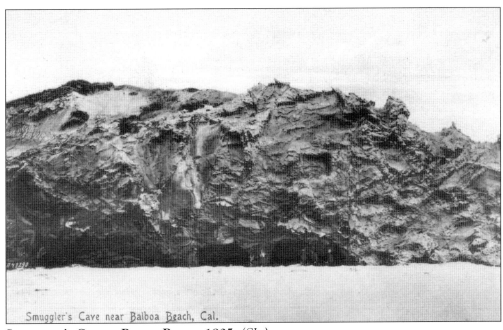
SMUGGLER'S COVER, ROCKY POINT, 1905. (SL.)

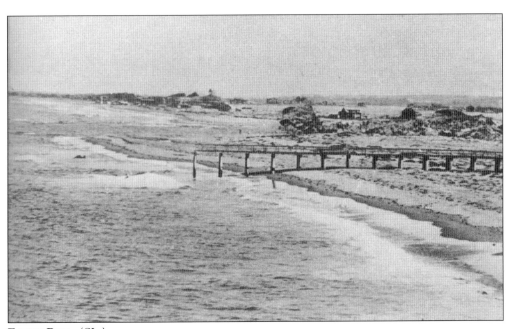
EARLY PIER. (SL.)

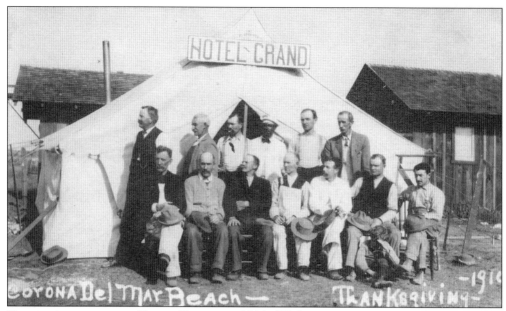

THANKSGIVING AT THE HOTEL GRAND IN 1911. (SL.)

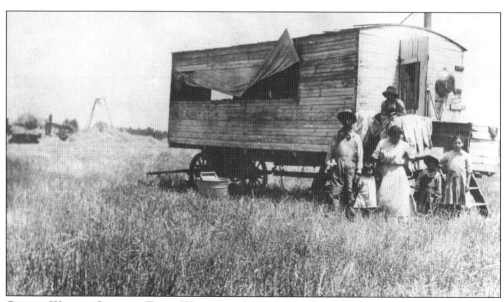

CHUCK WAGON SERVING FARM WORKERS. (NHNM Archives.)

Early Attempts at Land Sales, c. 1920s. (NHNM Archives.)

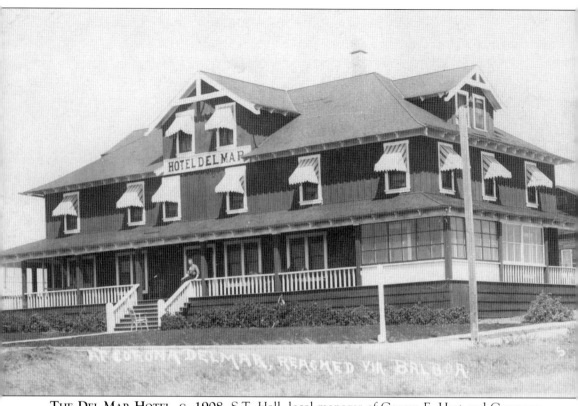

THE DEL MAR HOTEL, C. 1908. S.T. Hall, local manager of George E. Hart and Company, planned and supervised the building of the Del Mar Hotel. Opening on July 20, 1907, with 30 rooms, the hotel had closets, toilets, and a bathroom on each floor. Gas lighting, fireplaces, and a ladies' parlor were other advertised features. Verandas circled the hotel on three sides, allowing views of the ocean, bay, or hills, for diners eating on the screened porches. A telephone line and landscaping were in place by the summer of 1908, although paved streets and sidewalks would have to wait almost a decade to be completed. (Gray Collection.)

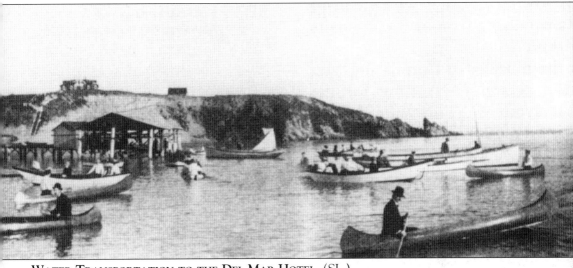

WATER TRANSPORTATION TO THE DEL MAR HOTEL. (SL.)

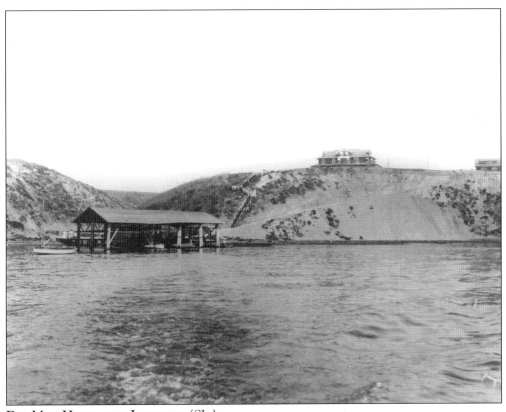

DEL MAR HOTEL AND LANDING. (SL.)

A LONG OVERLAND JOURNEY. Corona del Mar's isolated location discouraged residential development. (NHNM Archives.)

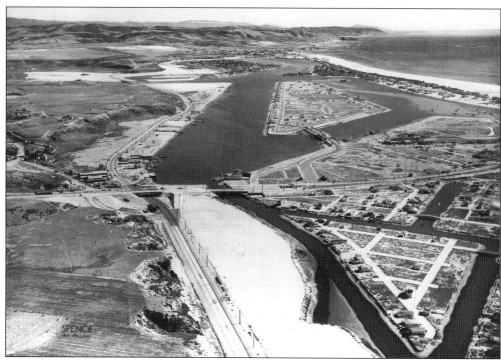

PASTORAL VIEW. This Spence Aerial Company photograph shows the open land of Corona Del Mar in the 1940s. (NHNM Archives.)

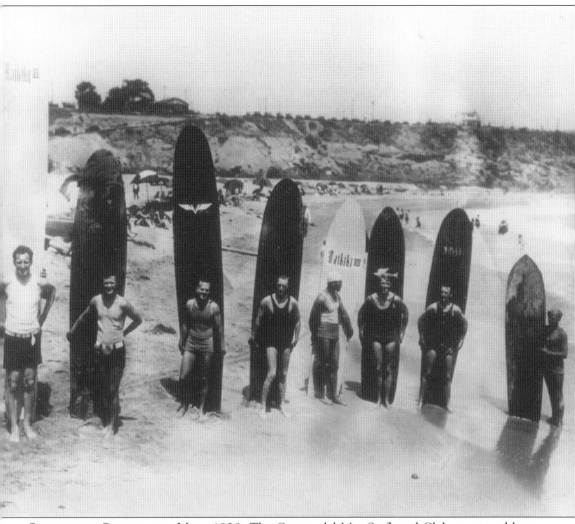

SURFING AT CORONA DEL MAR, 1928. The Corona del Mar Surfboard Club, sponsored by Captain D.W. Sheffield (the manager of Starr Bathhouse), hosted the Pacific Coast Championships on August 5, 1928. This was the first surfing contest held on the mainland. It attracted competitors from all of the area surf, athletic, and swim clubs, including Duke Kahanamokee, Harold Jarvis, Art and Gerald Vultee, Clyde Swenson, and Dennie Williams. Tom Blake, using a replica of a Hawaiian board called an "olo," won the paddle board event in front of 10,000 spectators. The event continued until 1941, when World War II ended the competitions. Duke Kahanamoku, a member of Antar Deraga's Life Saving Corps, was known locally not only for his swimming and surfing records, but also for his earlier life-saving operations. Duke used a surfboard in place of a dory boar. (NHNM Archives.)

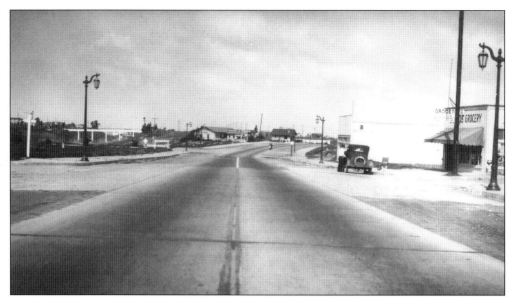

ROAD TO CORONA DEL MAR. Before the highway was extended in an opening ceremony with Mary Pickford in 1931, visitors to Corona del Mar were required to take the rugged route along this dirt road. Early automobile travelers had to wear proper driving clothing to arrive without a layer of dust. Later motorists did not have to fight beach traffic. (SL/NBHS.)

THE CORONA DEL MAR TUNNEL. Construction began in June 1931 to build an automobile tunnel to bring traffic under Newport Bay. The route took autos from the end of the Balboa Peninsula to present-day Corona del Mar State Beach. Newspaper accounts show the start of construction, but do not indicate a date of completion. The Long Beach Earthquake in March 1933 is blamed for the destruction. Speculation at the time hinted that construction companies cut costs by using inadequate building materials, but this charge was never proven. (Gray Collection.)

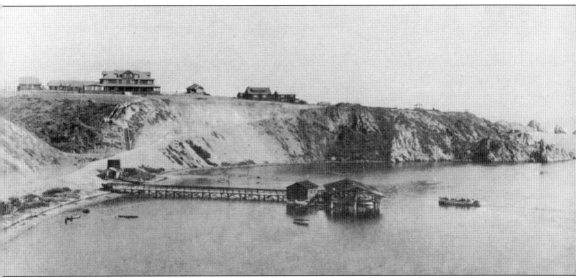

Corona Del Mar. The early water supply for Newport came from a cove on the west side of the bay, where there was a fresh spring. A large pipe was installed and almost every week a barge was taken from the old landing, anchored for 24 hours to be filled with water, and returned with the tide to supply water for residents and visitors. Corona del Mar did not have a reliable source for fresh water, and this was a hindrance to development. The water issue was one of the factors that led to annexation to Newport Beach. (SL/NBHS.)

THE FIVE CROWNS RESTAURANT. The Hurley Bell Inn was built in 1936 by Matilda "Tillie" Lemon MacCulloch after *Ye Olde Bell*, an inn at Hurley-on-Thames, 35 miles west of London, England. Photographs provided the design model for local architect Shelby Coon. Even though the facility was slated to be an inn, the MacCullochs decided to make it their home until Shelton McHenry and Bruce Warren, operators of the Los Angeles Tail o' the Cock Restaurant, leased it for a branch of that Hollywood eatery. This new restaurant opened on October 28, 1943, with Neva and Larry Beaulac as manager and cook. H.M. Keenholtz took over the managerial duties the following year. After World War II, the restaurant was leased to the Frank and Van de Kamp families and was remodeled and opened as the Five Crowns. It operated continuously until the 1980s, when it was purchased by the Lawry's Food Corporation. (SL.)

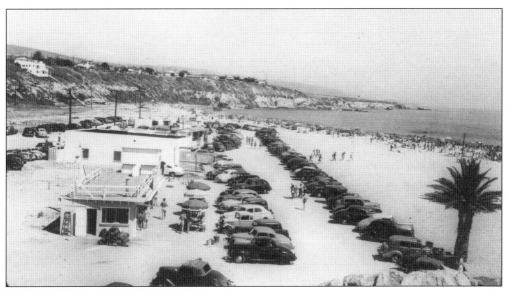

BIG CORONA, C. 1940. (Gray Collection.)

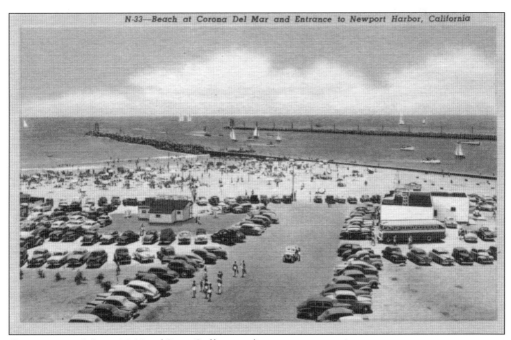

CORONA DEL MAR, 1940S. (Gray Collection.)

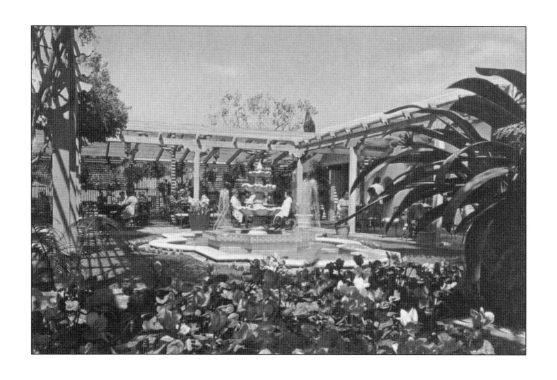

THE SHERMAN GARDENS, 1960S. H.M. Sherman began his career as a teacher and ended up, after a lifetime of astonishing career moves, as a former governor of Arizona, board member of major banking institutions in Arizona and California, railway organizer, and real estate investor and developer. After Sherman's death, the Sherman Foundation was established by his heirs and his associate Arnold D. Haskell in 1951. The non-profit philanthropic, educational, and humanitarian organization sponsored hospitals, youth groups, scientific research, and the arts. The Foundation has also established and maintains the Sherman Foundation Center in Corona del Mar. Specimens of rare plants are on permanent display, complimenting displays of special seasonal and flower programs. Gallery, gift store, and meeting areas are located at the Gardens on East Coast Highway. (SL.)

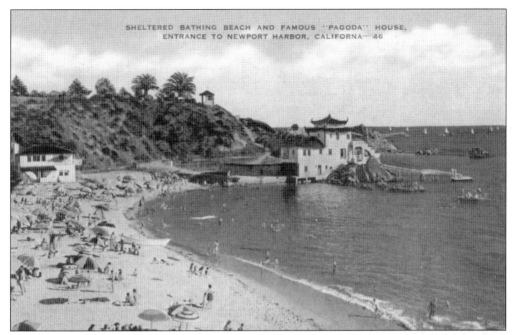

THE PAGODA HOUSE. The view of this unique house was a popular image for tourist postcards until the structure was remodeled. (SL.)

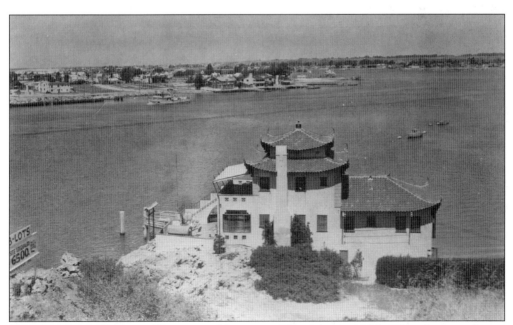

THE CHINA OR PAGODA HOUSE AT NEWPORT HARBOR, C. 1930. This photograph was taken from vacant lots above. Note the wooden sign on the bottom left offering lots for $6,500. (NHNM Archives.)

CORONA DEL MAR HIGH SCHOOL DURING CONSTRUCTION. Located at 2101 Eastbluff Drive, the campus's 31-acre site was cleared and graded in 1962. The school opened for students in 1962. Today the campus has been recognized with the awards for Excellence in Education in 1984 and California Distinguished School in 1998. This *Ebbtide*, the school yearbook, image shows the first stages of construction. (CdMHS.)

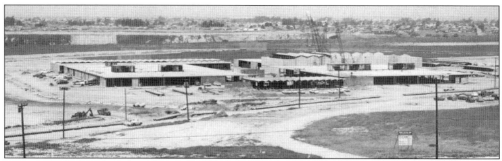

CORONA DEL MAR HIGH SCHOOL, 1962. The school was finished in time for students to enter for fall term in 1962. (SL.)

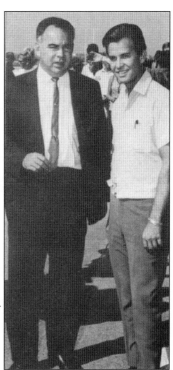

DICK CLARK AT CORONA DEL MAR HIGH SCHOOL. The *Where the Action Is* television show was filmed at Corona del Mar High School in 1963. Paul Revere and the Raiders, Peter and Gordon, Mary Wells, and the Yardbirds performed while the "Go-Go" girls danced. Band member Paul Revere's leap into the school pool and film of the event was used for the show's opening credits. (CdMHS.)

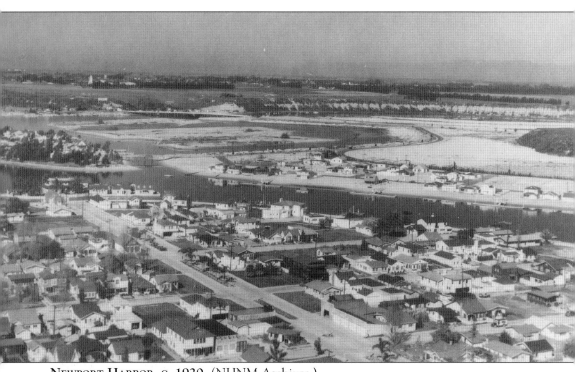
NEWPORT HARBOR, C. 1920. (NHNM Archives.)

Four
THE ISLANDS

Shifting sand and dredging efforts make the precise mapping of Newport a difficult task. Local residents used various names to describe islands and island-like formations, such as Snipe, Newport, Balboa, Shark, Lido, Linda, Harbor, Bay, and Collins. With each round of dredging from the turn of the century until the 1940s, islands were created and enlarged.

The only island suitable for early residential construction was Bay Island, and summer cottages were quickly built there. Balboa Island required significant improvements, which were begun by W.S. Collins immediately after the turn of the century. Collins' miniature island with its single seawall and his concrete home was completed for his new bride, but his dredging, grading, and installation of an imported concrete seawall at nearby Balboa Island failed to attract investors, since the majority of the island lots continued to flood despite the seawall. Lido Island, originally named [Pacific] Electric Island, was first dredged by former Pacific Electric conductor W.K. Parkinson in 1923, but development would wait until 1928 when W.C. Crittenden took over interests in the island. Buyers were elusive and the project was transferred to the Griffith Company during the Great Depression. It would take until the mid-1950s for the lots to be completely sold. Harbor Island, a joint project of Joseph A. Beek and Louis Briggs, opened for construction in the spring of 1928. Linda, named after the daughter of Irvine Company president, was created during the harbor dredging in 1936 but would take several decades to acquire its present name and be developed.

Early island residents had difficulties with sewers, utilities, and most importantly, with a reliable supply of fresh water. The earliest island utilities and services needed constant attention. Electric and telephone lines required frequent adjustment to supply uninterrupted service. Lido Island, with wide, paved streets and high-grade utilities, was a stark contrast to earlier island development, with open sewer pipes and lines of people each morning waiting to carry buckets of fresh water to their cottages. Harbor dredging continued to alter island geography, especially during creation of the new harbor in 1936. Post-World War II improvements created buildable terraces and bluffs for today's developments.

Transportation to most islands was by boat or canoe, but for Balboa a ferry service was established. First operated as a private enterprise, the ferry was eventually converted to a municipal service. Longtime ferry operator Joseph Beek was the best-known operator, and the Beek family continues to operate the auto ferry boats today. By 1911, a concrete bridge had replaced a temporary wooden one for access to Balboa Island.

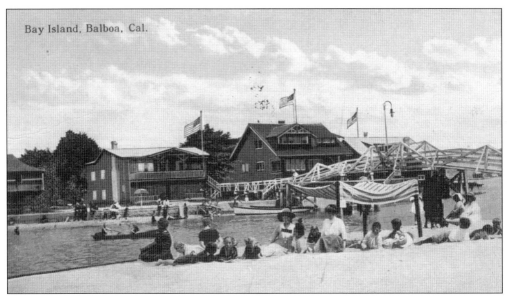

BAY ISLAND, C. 1900. Wooden planks over marshy ground allowed residents and visitors to walk to Bay Island. The lots were the only area high enough to escape the flooding that covered other nearby islands and sandbars. (SL/NBHS.)

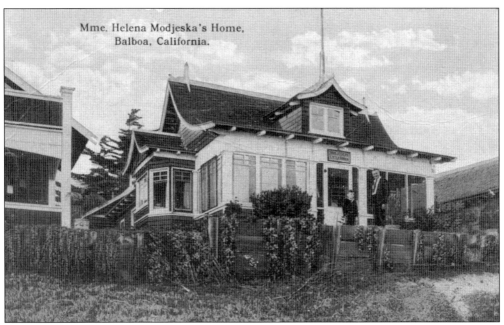

MADAM MODJESKA'S BAY ISLAND HOUSE. Even though Helena Modjeska, a well-known stage actress, lived only a year in her third island house, visitors continued to call the island Modjeska Island. The house was demolished in 1941. (SL/NBHS.)

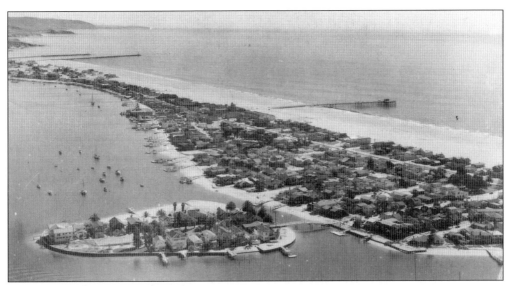

BAY ISLAND. (NHNM Archives.)

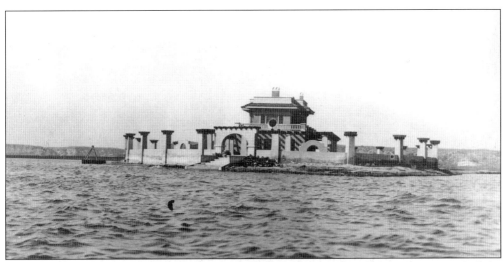

COLLINS CASTLE. W.S. Collins' house, constructed of imported German concrete, included a boat landing, murals, and a seawall. It was built for his fourth wife Apolena. James Cagney's brother owned the house in the 1930s and some still refer to the island as "Cagney's Island." During World War II, the house was occupied as a military installation. (NHNM Archives.)

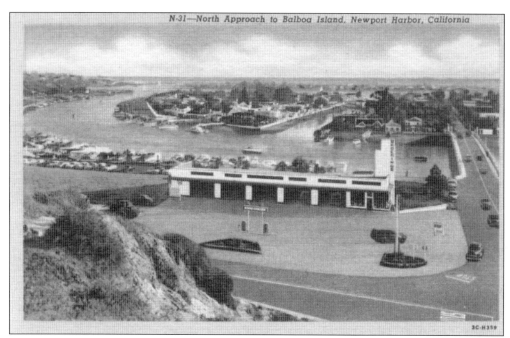

BALBOA ISLAND BRIDGE, C. 1940. W.S. Collins hired Joe Beek to construct a wooden bridge from Balboa Island to the mainland in 1912. The 12-foot-wide bridge, used to transport building materials and supplies via horse and wagon onto Balboa Island, stood for 12 years. (NHNM Archives.)

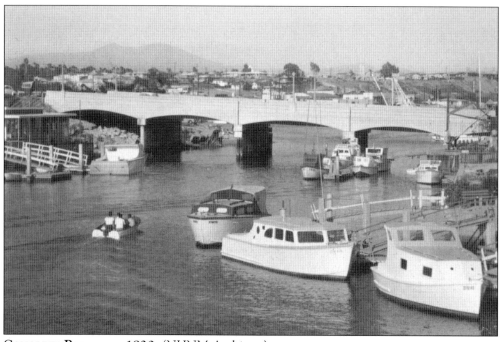

CONCRETE BRIDGE, C. 1930. (NHNM Archives.)

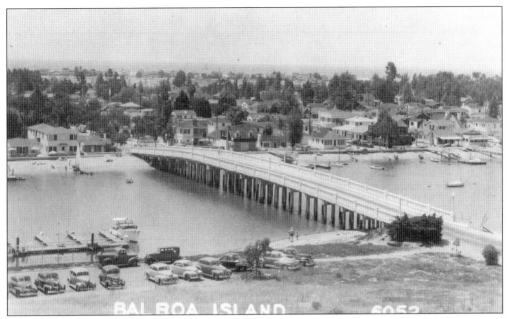
BALBOA ISLAND, C. 1940. (SL/NBHS.)

BALBOA ISLAND, C. 1950. (Gray Collection.)

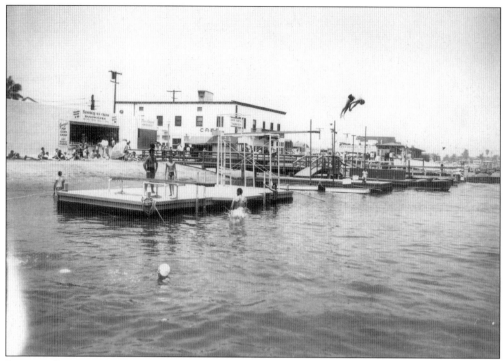
BALBOA FERRY LANDING, C. 1940S. (NIINM Archives.)

JOLLY ROGER RESTAURANT MENU CARD, C. 1960S. Famous for double-decker burgers, barbecue steak sandwiches, and ice cream sundaes, the eatery was located at 203 Marine Avenue on Balboa Island. Today Wilma's Patio Restaurant occupies the site. Wilma's merged with the Jolly Dolphin that formerly occupied the building. (Gray Collection.)

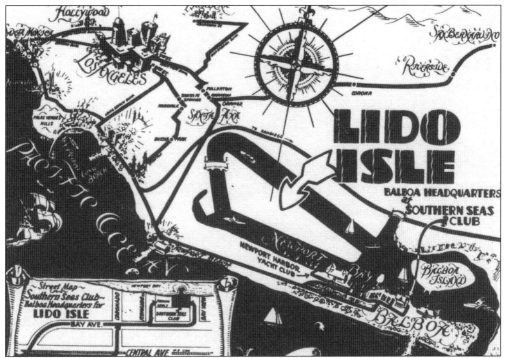

LIDO ISLE. Even though the island was dredged and filled in 1923–4, Lido remained undeveloped for several years. W.K. Parkinson had dreams for his island, but his death in 1927 left the land to new owner William Clarke Crittenden to develop. John P. Elsbach subdivided and sold lots. Swiss architect Franz Herding was engaged to create a Mediterranean-themed design. Streets, or *vias*, were given French and Italian names. A new clubhouse with a high tower overlooked tile-roofed models, walled lots, and patio gardens. (NHNM Archives.)

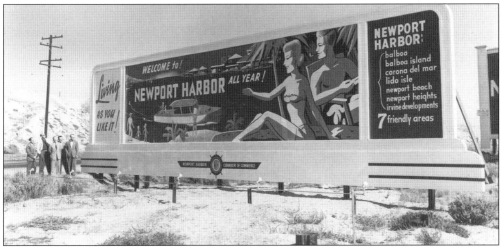

LIDO ISLAND DEVELOPMENT. W.C. Crittenden and a group of investors constructed temporary utilities and model houses on Lido Island in 1928, but the subdivision's minimum $6,200 price tag was beyond the means of most investors. The city promoted the project with bonds for island improvements, which were completed by the Griffith Company in 1930. (NHNM Archives.)

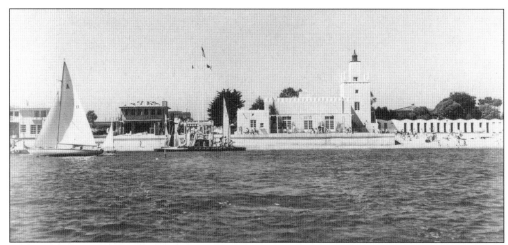

LIDO ISLAND. Newport residents came to ride bicycles on the smooth streets and enjoy the harbor sights by street lights, but the vacant lots on Lido Island were transferred to the Title Insurance and Trust Company of Los Angeles. The company slashed prices, but still held considerable inventory when Paul A. Palmer took over the land sales in 1935. Even with deeply reduced prices, the last undeveloped lots had to wait until 1955 to be sold. (NHNM Archives)

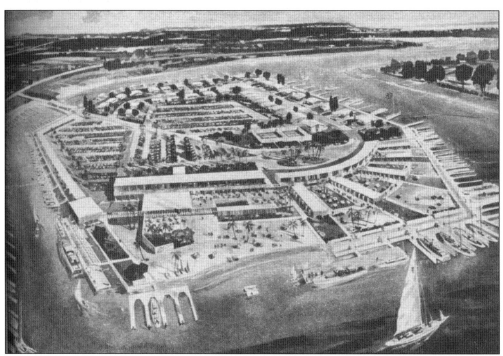

LIDO ISLAND C. 1928. W.K. Parkinson had high hopes for his newly created island before his death in 1927. William Clarke Crittenden purchased partial interest hiring developer John P. Elsbach and Swiss architect Franz Herding. The Mediterranean-themed architectural plan called for tile-roofed structures, and streets with French, Italian, and Spanish names. Despite the model houses, temporary utilities and a new, posh clubhouse, few investors noshing on a free lunch in 1928 could be enticed to invest the $6,200 minimum purchase price. (NHNM Archives.)

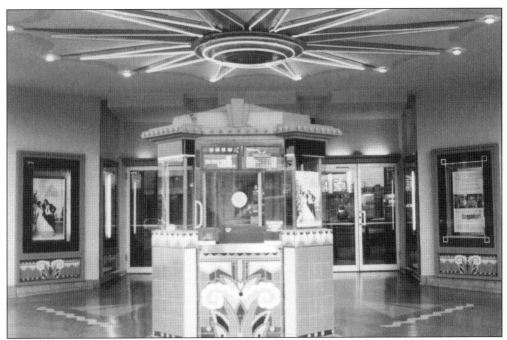

LIDO THEATER, 2003. The first theater in Balboa was constructed by J.P. Greely in 1913. It closed when the Ritz Theater on Central Avenue (now Balboa Boulevard) opened in 1928. A new Ritz Theater opened on Lido in 1939 and the first Ritz was renamed the Balboa Theater. The Balboa venue continued to show first-run movies until it became an adult theater in the 1960s and then a revival house in the 1970s. The theater closed in 1992 and has been the focus of renovation efforts for the last eight years. The Lido Theater shows first-run movies and is one of the screens used in the annual Newport Beach Film Festival. (Gray Collection.)

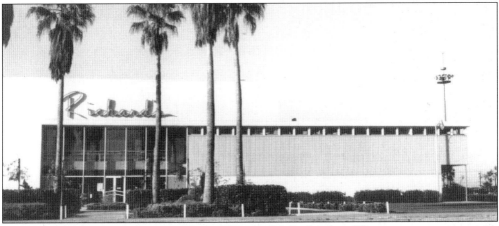

RICHARD'S LIDO MARKET, C. 1954. O.W. "Dick" Richard, a Wisconsin native, was the manager of Richard's Lido Market. Their motto was "Service, Variety, Quality and Honesty." The store was constructed in 1946 by Stephen Griffith, to offer residents on Lido Island the opportunity to shop without leaving the village. The unique shopping experience, which at one time included an organist playing shoppers' requests, earned the store a national reputation and an award for "Retail Store of the Year" in 1954. The "Goofoffer's Club" met regularly from opening until closing time at the store, enjoying coffee and conversation. (CSUF.)

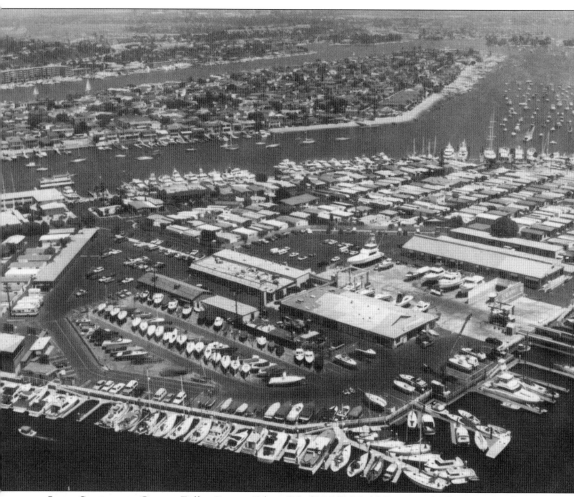

LIDO SHIPYARD. George Fuller Peters, Edgar "Ned" Hill, Hadd Ring, and Thomas Henderson purchased equipment from C.F. Ackerman, an Azusa firm, and constructed Lido Shipyards in 1941. Production of U.S. Navy craft went on nonstop until the firm was sold to Consolidated Steel in 1945. Curci-Turner later purchased the peninsula, including the shipyard, and L. "Buck" Ayres took ownership of the shipyard facility in August 1949. (NBNM Archives.)

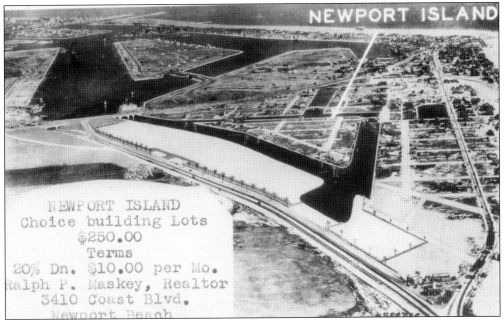

NEWPORT ISLAND. The West Newport canals and Newport Island were created in 1907 in a dredging project between present-day Fortieth and Sixtieth Streets, organized by a consortium of investors called the Orange County Improvement Association. Despite heavy promotion, the area proved to be less than a financial boon for investors. Real Estate developer Ralph Maskey took over the project in 1929, dredged the silt-filled canals, and spent nearly $100,000 for street improvements to the island. Storms had destroyed most of the earlier development, including the saltwater swimming pool and the West Newport Pavilion. (NHNM Archives.)

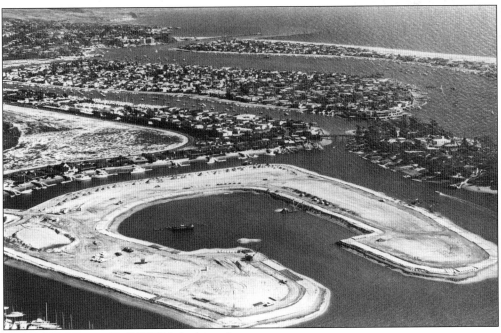

LINDA ISLAND, 1967. (NHNM Archives.)

NEWPORT HARBOR. Harbor proponents attempted to change the name of the city to Newport Harbor in 1958, but the charter amendment failed to be adopted. (Gray Collection.)

Five
THE HARBOR

The *Vaquero* proved that the harbor could be navigated, but other craft were not always as successful in their attempts. Although steamers were recorded at Port Orange as early as 1870, haphazard dredging, as well as natural and farm-produced erosion, caused silt and sand to accumulate in the bay. Safe navigation into the bay could not be guaranteed, and as a consequence many lives and boats were lost. Ships ran aground on sandbars or became mired in marshy shallows. Most visitors anchored offshore and entered Newport in flat-bottomed dory boats, often arriving by way of a quick dip in the surf.

Prior to the city's establishment of a lifeguard service, local volunteers offered assistance to swimmers and to capsized boats and ships. The Frost Life Saving Corps was organized in 1913 and the Life Saving Corps succeeded it in 1923, with Martha and Antar Deraga as its principal organizers, and surfer and swimmer Duke Kahanamoku as a member. Joseph Beek was hired as the first harbormaster and he undertook the dangerous installation of harbor lights in the 1920s. The Deraga Family issued storm warnings from their Corona del Mar station beginning in 1919. The family was hired by the Orange County Harbor Commission to establish a meteorology and signal station at the harbor entrance to warn of dangerous surf conditions.

Despite private, city, and county dredging, silt and waste from the valley were critical concerns. Flooding was an ongoing problem facing early residents. The storms of 1915 and 1916 returned parts of the bay to mud flats and mobilized a group of "Harbor Boosters" to lobby for changes. The story of Newport Harbor's development, with lobbying, political intrigue, and maneuvering filling newspaper front-pages for many years, is a subject worthy of a separate book. City and county bonds were first rejected and then passed, but it would take until 1936 for a new harbor to finally be dedicated. The federal government completed several surveys, the first after the *Vaquero's* entrance, but the question of the establishment of a commercial port was raised and continually left unanswered. As early federal funds went to the commercial harbors in San Pedro and Los Angeles, Newport began to develop into a premiere sports harbor instead, thanks largely to the efforts of Lew Wallace, John Rogers, Joseph Beek, and other boosters.

City jetties rebuilt in 1919 were destroyed by storms. Replacement jetties proved inadequate, sinking to a level low enough to become totally ineffective and in fact causing, not preventing, erosion to ocean-front properties. With volunteer efforts, bonds, and local funding, the harbor developed slowly. The harbor today is under control of the Harbor Patrol, and the issue of silt accumulation and jetty construction continues to be the subject of political debate.

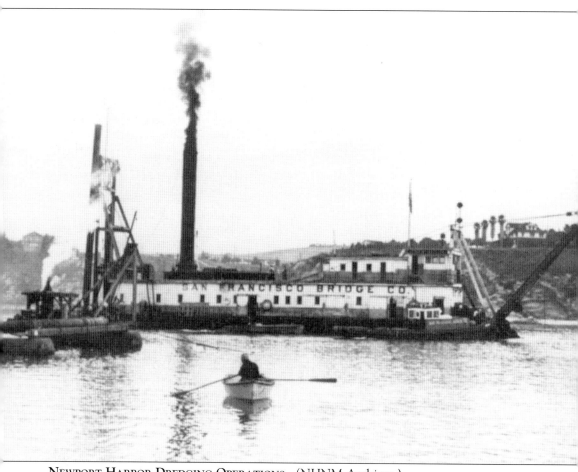
Newport Harbor Dredging Operations,. (NHNM Archives.)

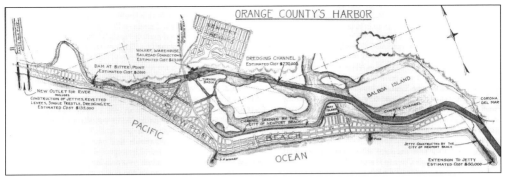

THE EARLY HARBOR, C. 1900. (NHNM Archives.)

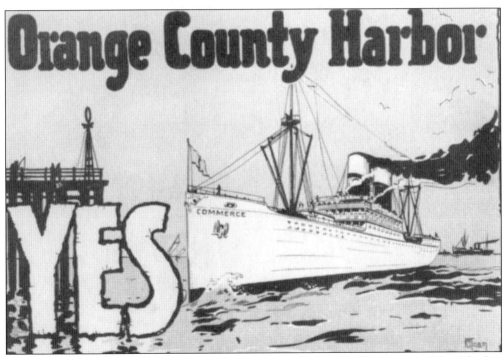

HARBOR BONDS, 1933. George Rogers, city engineer Richard L. Patterson, and local harbor booster A.B. Rousselle obtained half of the funds required to extend and rebuild the jetties and complete dredging. The Public Works Administration, a Depression-era federal alphabet agency, contributed almost a quarter of the additional needed moneys. This advertisement urged Orange County residents to make donations toward the last $640,000 that was required. Approval at the polls in 1933 proved that voters agreed with claims that the project would improve flood prevention and create jobs for local residents. (NHNM Archives.)

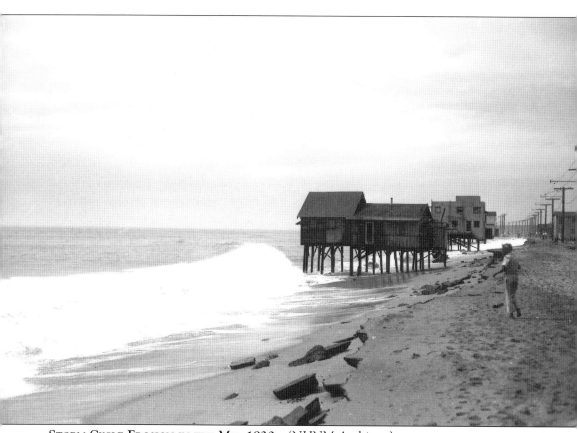
STORM CYCLE EROSION IN THE MID-1930S. (NHNM Archives.)

Erosion Damage, 1917. (SL/NBHS.)

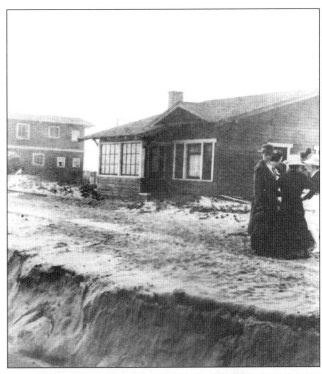

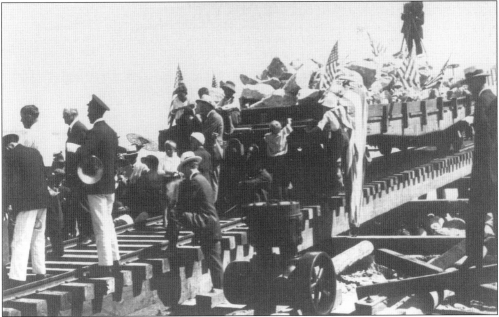

The Harbor Boosters. Los Angeles boaters encouraged construction of Newport jetties and dredging projects. A group of local residents, along with the Chamber of Commerce, established a fund in 1907 to create a safe, navigable harbor. W.W. Wilson, Albert Hermes, W.W. Crosier, Joseph Ferguson, A.A. Lester, John King, George T. Peabody, C.L. Lancaster, Frank Beckwith, J.H. Sharpo, C.S. Hemstreet, Lew H. Wallace, Terrel Jasper, John McMilian, C.A. Barton, and J.S. Wilkinson were charter members. (NHNM Archives.)

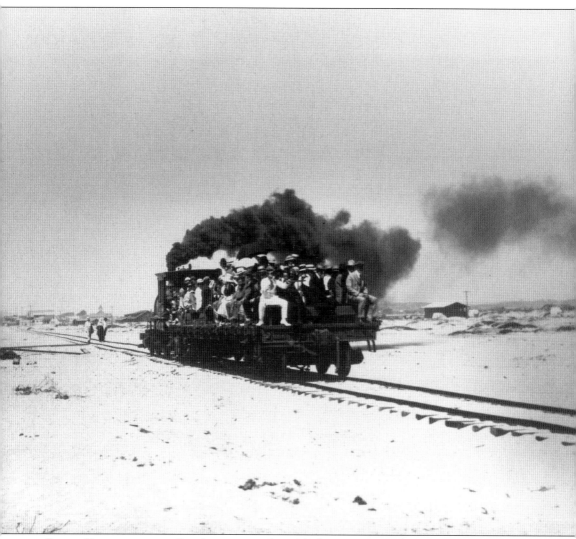

JETTY CONSTRUCTION. Bonds were voted in 1916 to construct the West Jetty, but by the 1920s, the structure was failing. An additional bulkhead was added in 1923. The right side on the surf side had been set aside for residential development, but erosion took the lots before they could be sold. (NHNM Archives.)

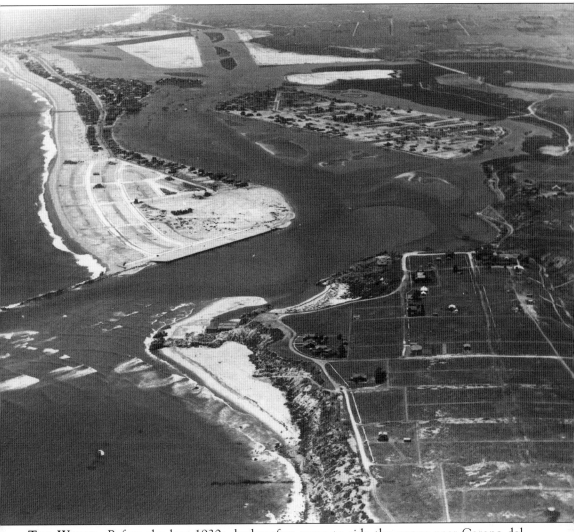

THE WEDGE. Before the late 1930s, bodysurfers came to ride the waves near Corona del Mar. The 800-foot cement jetty created huge waves that were a body surfer's dream. A new jetty changed the wave pattern. (SL/NBHS.)

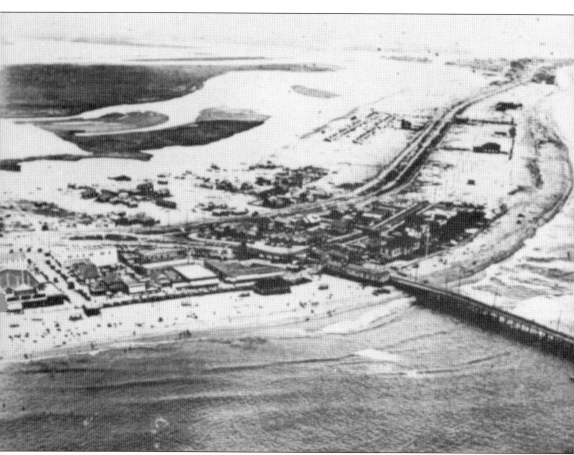

NEWPORT HARBOR. The new harbor opened on May 23, 1936, after decades of lobbying, several project designs, and extensive dredging. George Rogers presided as honorary captain of the port parade, in recognition of his efforts to create a safe harbor. A plaque at the harbor entrance is dedicated to Rogers, commemorating his two expeditions to Washington D.C. that were successful in obtaining federal funds even during the height of the Depression. (NHNM Archives.)

V.V. TUBBS AND FAMILY GO SAILING. The Tubbs had one of the earliest pleasure crafts on Newport Bay. The family maintained a vacation house next to Abbott's Landing in Bayside (now Balboa), sailing in a handmade boat which frequently capsized during their trips around the bay. (Sherman Library.)

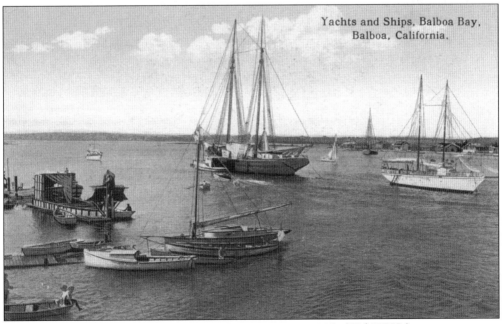

EARLY NEWPORT HARBOR YACHTS AND SAILBOATS, C. 1905. (SL/NBHS.)

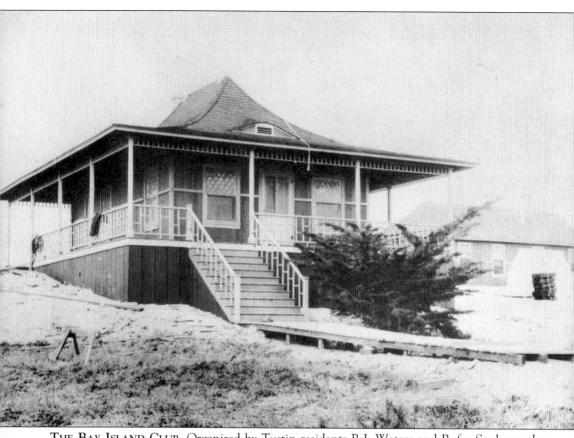

THE BAY ISLAND CLUB. Organized by Tustin residents R.J. Waters and Rufus Sanborn, the club incorporated on March 20, 1903, with 24 lots and share offerings. Waters and Sanborn purchased the barn-like building and land for $350. (NHNM Archives.)

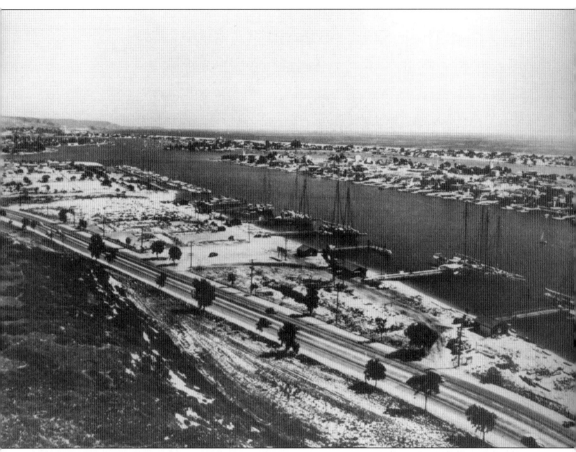

NORTH CHANNEL, 1938. Farming was the principal activity on the land that would become Westcliff, Dover Shores, and Eastbluff. The Balboa Bay Club was constructed on waterfront land deeded to the city of Newport Beach from the Irvine Family. When the city faced economic crisis in 1938, proposals were made to lease the land for industrial and commercial construction. This acreage, on the frontage side of the bay between Bay Shore Acres and the Arches, was considered a prime location to produce city lease income to cover growing fiscal deficits. In other parts of Newport, residential lots were being signed over to the city to cover back taxes and for failure to pay improvement assessments. It would take until March 1948, for the idea of the Balboa Bay Club to be developed into a concrete plan, and for a lease to be signed. The tall ships pictured were berthed at military piers at the former Army Air Corps station. The *Goodwill, Pioneer, Enchantress, Verona, Vega,* and *Gloria Dalton* were used to patrol the bay during World War II. (SL/NBHS.)

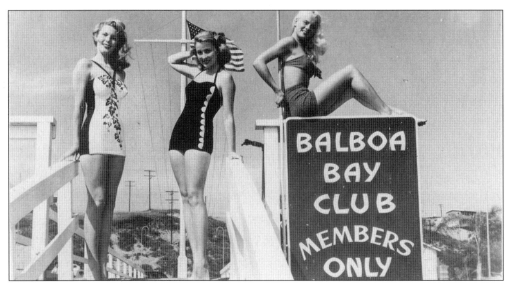

BALBOA BAY CLUB. Attorney Tom Henderson and real estate developer Hadd Ring were founders of the Harbor Investment Company. K.T. "Ken" Kendall teamed with attorney Howard Burrell, contractor George Holstein, business owners Walter Douglass and H.L. Hoffman, advertising executive John Roch, and Congressman Carl Hinshaw to create a family membership club with a dining room, swimming pool, and tennis court. This group was officially organized as the Newport Bay Company. The Irvine Family thought the club would be an excellent use for the land his family had deeded to the city. Today the club has undergone an extensive remodeling. (NHNM Archives.)

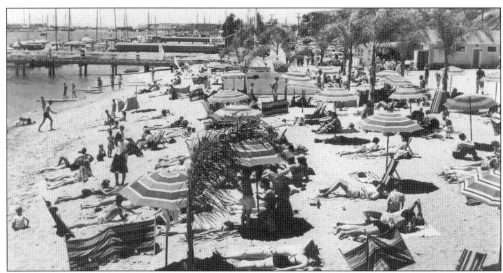

BBC. Local officials supported the idea enthusiastically, given the guaranteed income the club would contribute to the city coffers. Initial memberships were sold from a hamburger stand. The first investment was the BBC swimming pool. *The Bay Window*, the club's magazine, premiered in 1951. Over the years the BBC has hosted important political and business meetings, celebrity parties, and amateur and professional sporting events. The membership roster includes people of not only of local stature, but of national and international prominence. (NBNM Archives.)

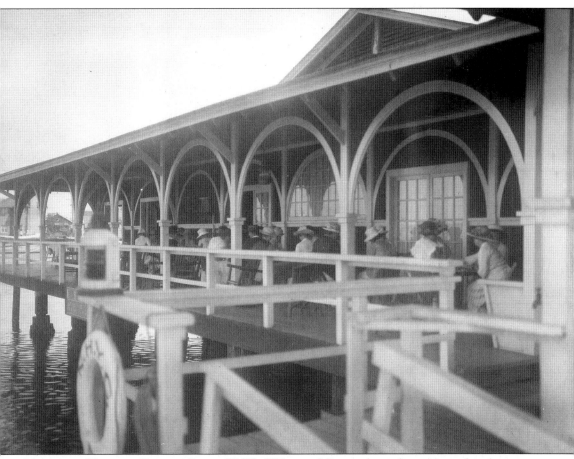

NEWPORT HARBOR YACHT CLUB. W.W. Wilson of Riverside and a group of investors constructed what would become the Newport Harbor Yacht Club on land owned by the East Newport Town Company. Dr. Albert Soiland donated land and buildings at the East Newport Pavilion for the establishment of the club in 1916, and was named the group's first commodore. Dr. Soiland was also the co-founder of the Transpacific Yacht Club, which sponsored races from Newport Harbor to Honolulu and Tahiti. (NHNM Archives.)

SOUTHLAND SAILING CLUB, 1926. This early sailing club was established May 30, 1926, and would be transformed into the Balboa Yacht Club in February of 1928. (NHNM Archives.)

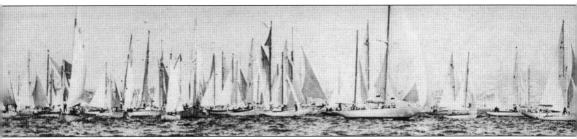

NEWPORT TO ENSENADA, MEXICO RACE. This race held every April is the largest international race. The Newport Ocean Sailing Organization, the organizing body, was founded in 1948 to encourage amateur sports—sailing, boating, and seamanship. The first race was called the "Governor's Cup" and had 117 entrants. Only 65 of those completed the race due to high winds. Today, typically over 500 boats enter each year. Skippers include movie stars and politicians, as well as world-class sailors. Many participants have competed in the race for 20 or 30 years. Some sailors claim 40 races. (Gray Collection.)

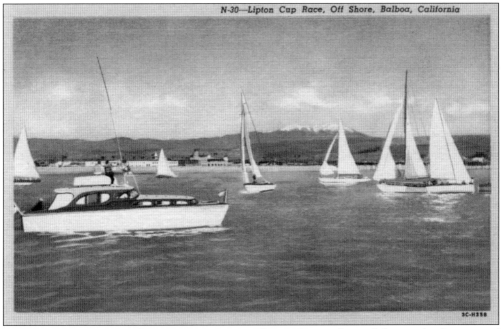

LIPTON CUP, C. 1947. Irish tea entrepreneur Sir Thomas Lipton donated the cup for the victor of the series of three Pacific Coast races. The first race was hosted by a San Diego yacht club in 1904, and was won by the Newport Beach Voyagers Yacht Club in 1947. The Balboa Yacht Club carried on that tradition with a sweep of the cup in five straight sweeps beginning in 1992. The Sir Thomas Lipton Challenge Cup was organized from the BYC again in June 1996. (Gray Collection.)

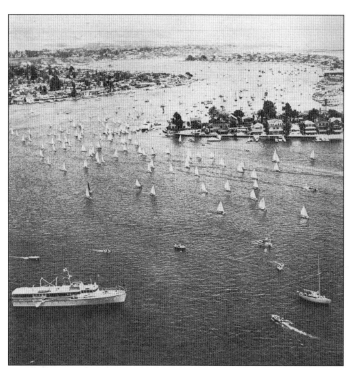

FLIGHT OF THE SNOWBIRDS, C. 1954. Beginning in 1935, with joint inspiration from Dr. Albert Soiland and local promoter Harry Welch, the yearly Flight was open to young people until 1969. The Flight of the Lasers replaced the early Snowbirds race. Soiland was one of the enthusiastic sailing pioneers in Newport Harbor. He was instrumental in the selection of the Snowbird as the monotype for the 1932 Olympics in Los Angeles. (NHNM Archives.)

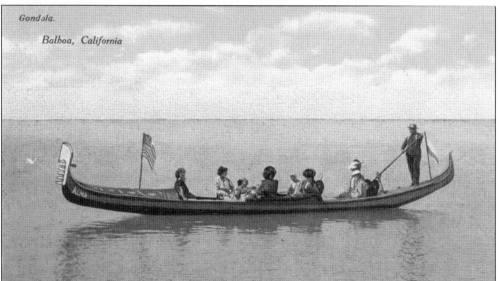

TOURNAMENT OF LIGHTS PARADE. John Scarpa is given credit for organizing the first lighted boat parade in 1907. Along with many others, Scarpa strung Japanese lanterns from his gondola. His fame came the following year, when others followed his boat around the harbor. By 1913, the "Illuminated Water Parade," as it was then called, had formal judging and prizes. Two years later, the spectacle was enlarged to include underwater mines, set off to add interest to a mock boat and fire rescue. Joe Beek revived the parade after a hiatus during World War I, and children's boats and floats were featured in the parades of the 1920s. By the 1930s, with the Newport Yacht Club sponsoring the event, historic numbers of participants entered and separate divisions were created. (SL.)

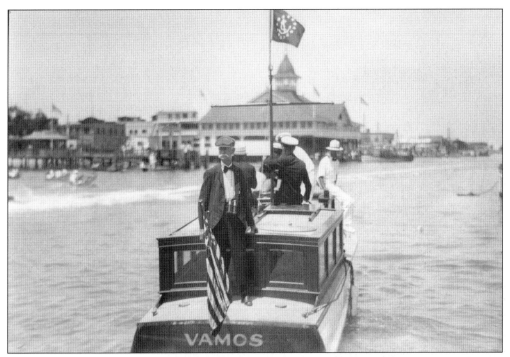

JOE BEEK AND THE VAMOS. Beck first toured Newport and Balboa in 1907 as a student at Throop Institute (later called the California Institute of Technology). He established a ferry service to Balboa Island and was one of its most noted supporters. Beek and the *Vamos* coordinated and led the yearly Tournament of Lights Parade for many of the years between 1919 until 1949. (NHNM Archives.)

TOURNAMENT OF LIGHTS PARADE C. 1954. City employees started another tradition in December 1946, towing a barge around the harbor with carolers and a lighted pine tree. Ferryman Joe Beck added a small Christmas tree to his ferry and began to follow the barge. A new parade tradition was established, despite the 1949 city decree that the earlier parades would not be sponsored. The Newport Harbor Christmas Boat Parade, hosted today by the Commodores Club of the Newport Beach Chamber of Commerce, is considered to be one of the nation's top holiday attractions. (NHNM.)

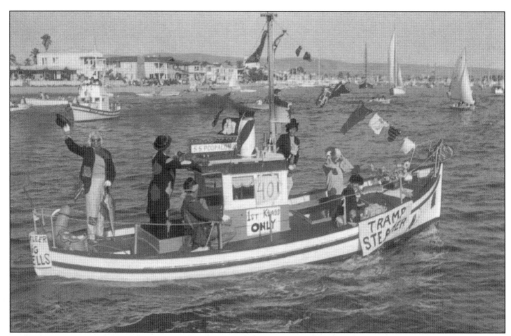

TRAMP STEAMER. The Newport Character Boat Parade was established by Newport Harbor in 1955. This parade evolved into the Old Glory Boat Parade. The American Legion Post 291 sponsors the floating patriotic tribute featuring the American flag. (NHNM Archives.)

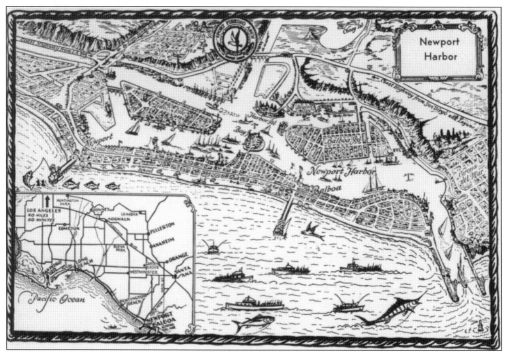

NEWPORT HARBOR MAP, C. 1946. Produced by the Newport Harbor Sport Fishing Association, this map shows 27 sport fishing landings, 10 daily live bait boats, 32 trolling boats, and one live bait barge all operating in the harbor. (NBMM Archives.)

Irvine Terrace, c. 1950. (NHNM Archives.)

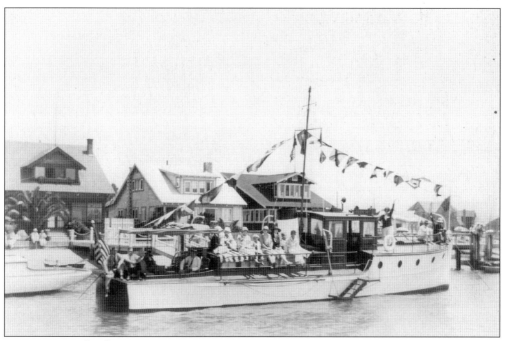

Beacon Bay. (SL.)

125

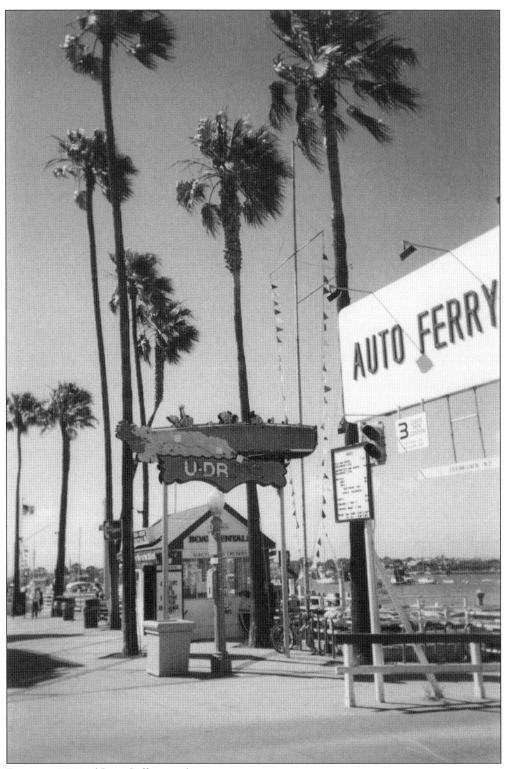

Balboa, 2003. (Gray Collection.)

Acknowledgments and Sources

Numerous articles, texts and biographies were consulted in preparation of this text. County histories, city directories, vertical files and biographies located in the collections of the Santa Ana Library, Los Angeles Public Library, Allen County Library Genealogy Department (Fort Wayne, Indiana) and branches of the Newport Beach Library were also examined.

The *Santa Ana Blade*, *Santa Ana* (Orange County) *Register* and the *Los Angeles Times* provided background research. Selected articles from the *Newport Ensign* and the *Daily Pilot* supplied additional details. *The Tales of Balboa*, an online weekly journal produced by Jim Fournier, and the *Balboa Beacon News*, edited by Kay Wassall-Kelly and Bill Kelly, both feature photographs and local history articles. These journals provided unique personal insights into local events and personalities.

The Newport Beach Oral History Collection at California State University, Fullerton, provided a wealth of information into the political history related to real estate and harbor development.

My thanks to Joe Tunstall for sharing his personal photographs and stories about the Balboa Fun Zone and to Art Gronsky for allowing his childhood and sport fishing recollections to be added to the CSUF Oral and Public History Collection.

The displays and photographic archives at the Newport Harbor Nautical Museum were important in documenting key events and locations. The Newport Beach Historical Society Collection and the postcard file at the Sherman Library in Corona del Mar offered turn of the century images. The Heritage Hall at Newport Harbor High School provided a rare look into a school archive, while the yearbook collection at Corona del Mar High School yielded interesting history. My sincere appreciation to Dr. William O. Hendricks, director of the Sherman Library; Dr. Sheli O. Smith, director of the NHNM; Webster Jones, director of Heritage Hall; and Ruth Ann Williams, librarian at Corona del Mar High School. My thanks to First American Financial Corporation and Bob Roubian, proprietor of the Crab Cooker Restaurants, for permission to use their photograph collections.

THE *LYNX* IN NEWPORT HARBOR, 2003. Woodson K. Woods commissioned the square-rigged topsail schooner *Lynx*, which arrived in Newport Harbor in May of 2002 to participate in the youth programs at the Newport Harbor Nautical Museum. The 122-foot schooner is a replica of an 1812 privateer. (Gray Collection.)